T0000351

ICONS OF STYLE
Taylor Swift

First published in 2024 by Welbeck
An Imprint of HEADLINE PUBLISHING GROUP

1

Cataloguing in Publication Data is available from the British Library

ISBN 978 1 80279 836 4

Printed and bound in China by Leo Paper

Headline's policy is to use papers that are natural, renewable and recyclable
products and made from wood grown in well-managed forests and other
controlled sources. The logging and manufacturing processes are expected to
conform to the environmental regulations of the country of origin.

HEADLINE PUBLISHING GROUP
An Hachette UK Company
Carmelite House
50 Victoria Embankment
London EC4Y 0DZ

www.headline.co.uk
www.hachette.co.uk

ICONS OF STYLE
Taylor Swift

The story of a fashion legend

Glenys Johnson

WELBECK

CHAPTER 3

Signature Pieces

130

CHAPTER 4

Swift Impact

182

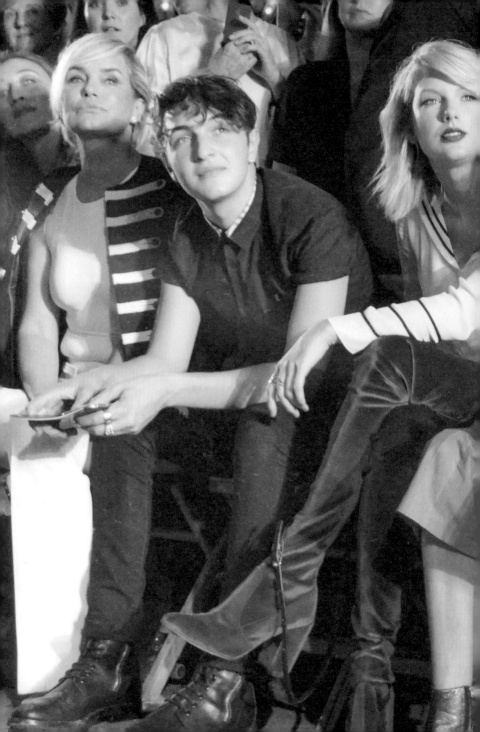

Introduction

Since releasing her first single – "Tim McGraw" – in 2006, Taylor Swift has proved the power of a pop star can go well beyond catchy songs and sold-out stadium tours. The Pennsylvania native would go on to build a career unlike anyone had seen before. Between record-breaking sales, high-profile legal cases (to maintain ownership over her music) and press scrutiny for romantic choices in her personal life, the singer-songwriter has come to use clothing as a communication tool in a way that adds a whole new layer to her fashion expression.

Born to Andrea and Scott Swift on December 13, 1989, Taylor Alison Swift's early years would resemble the lives of many middle-class Americans, spending much of her time running about the Christmas tree farm surrounding her home. She would reportedly write her first song at age eight as an outlet to channel frustration with feeling rejected by her peers in her class, sharing in a 2008 interview with *Women's Health*, "It's my way of coping [...] I write when I'm frustrated, angry, or confused. I've figured out a way to filter all of that into something good."

OPPOSITE A young Taylor sings the US National Anthem at the Detroit Pistons against the Philadelphia 76ers game in April 2002.

PREVIOUS Taylor sat alongside Yolanda Hadid, Anwar Hadid, Martha Hunt and Lewis Hamilton in the front row of the Tommy Hilfiger show during New York Fashion Week on September 9, 2016.

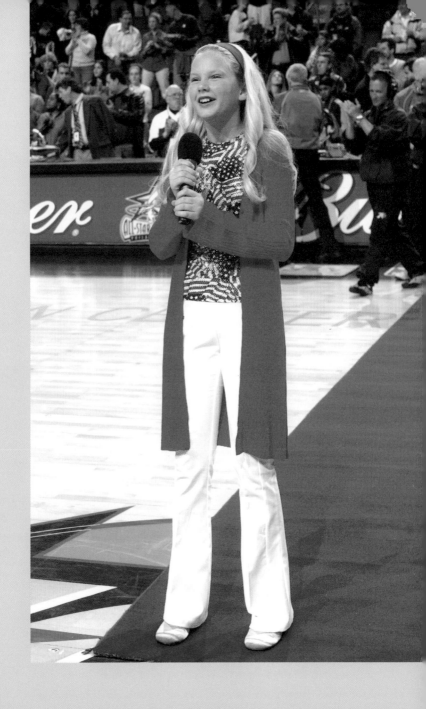

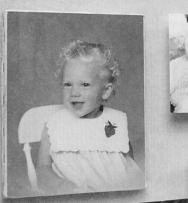

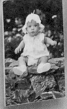

Photographs, Taylor Swift c.1990s

This collection of photographs gives a glimpse into Taylor Swift's earliest years with her family.

Courtesy of Taylor Swift

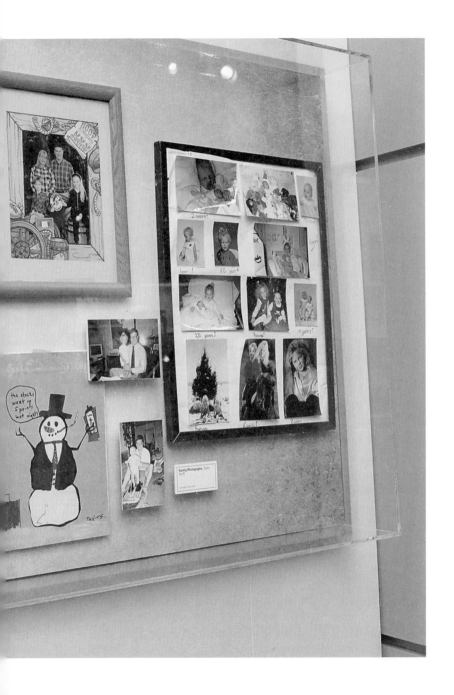

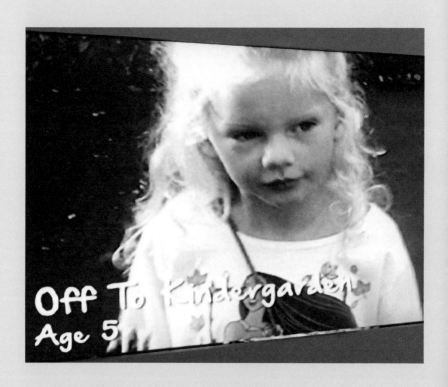

Off To Kindergarden
Age 5

PREVIOUS Baby photos and sentimental pieces are displayed in a glass case at "The Taylor Swift Experience" at the GRAMMY Museum, Los Angeles, on December 12, 2014.

ABOVE A candid shot of five-year-old Taylor is shown to visitors of 2014 exhibition, "The Taylor Swift Experience" at the GRAMMY Museum, LA.

Maintaining relatability to millions of fans across the globe while sporting custom Oscar de la Renta gowns on the red carpet and bejewelled bodysuits on stage is no easy feat. But Taylor Swift has managed to do just that (and it's arguably one of the reasons why her fans love her so much). And love her they very much do. Passionate "Swifties" have managed to cause an actual earthquake, after all.

When off the clock, Ms Swift's apparel choices would follow an evolution not unlike that of many young women across the world, experimenting with different looks, often comprised of high-street labels paired with more statement luxury touches. As her original fanbase grew up, so too did Taylor. And with playful "Easter eggs" (hints at messages, often related to her next music releases), the American songstress's looks were often as intriguing to fans as the lyrics to her songs.

Though supported by long-time stylist Joseph Cassell Falconer, Taylor has demonstrated her unique ability to steer her looks based on her preferences, reducing the risk of coming across as an overly curated product of the industry. *New York Times* writer Vanessa Friedman touched on this aspect of the star's success as a fashion icon, sharing, "Ms. Swift (with her stylist Joseph Cassell Falconer) has been her own wardrobe mistress, and her fans, many of whom show up dressed as their favorite Taylor, can relate."

As Taylor grows and evolves as an artist, fans and pop culture continue to be influenced both by what she communicates through her music and her wardrobe choices – and we're here for the ride.

Style

CHAPTER 1

Trajectory

The country girl next door

Taylor Swift (2006)

When the 15-year-old teen from small-town Pennsylvania signed her first contract with Sony Records in 2005, the thought of becoming a fashion icon was likely far from Taylor Swift's mind. Her wardrobe was pretty relatable for many teens her age at the time. The noughties was a decade of slouchy beanies, ruffle minidresses, pointed boots and headbands galore. And according to early promo shots of Taylor during this time, she was well and truly a lover of the trends. Her larger-than-life blonde curls could be seen draped down her graphic tees, worn with the quintessential low-rise blue jeans. Make-up staples included the famous shimmering cream eyeshadow that had a serious grip on many teen girls at the time, worn alongside some very Y2K stick-on gems worn around her eyes in the video for "Teardrops On My Guitar". And, of course, a tube of pink lip gloss was never far from Taylor's make-up bag. These looks demonstrated her relatability as the singer-songwriter girl next door.

Taylor attends the 41st annual Academy of Country Music Awards (ACM) held at the MGM Grand Garden Arena on May 23, 2006 in Las Vegas, Nevada.

"*Style is such
a* **personal** *thing;
it's your way to be
an individual.*"

TAYLOR SWIFT

Long-time fans of Taylor will remember when the star couldn't get enough of custom
cowboy boots like the ones pictured here during a 2007 performance in Las Vegas, Nevada.

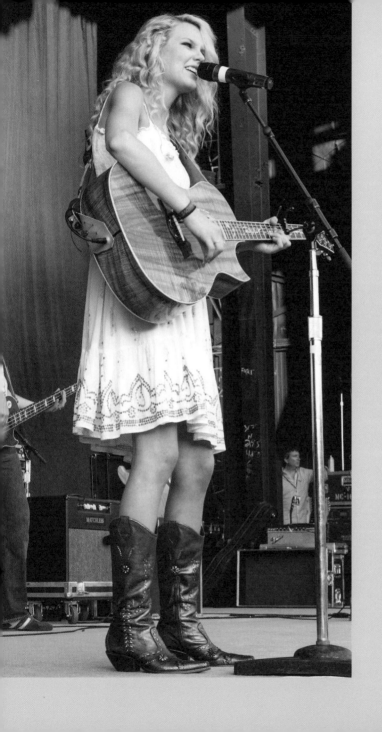

By 2006, Taylor's fame was quickly building with the launch of her self-titled debut album. She had become a fan favourite on CMT (Country Music Television) and her singles quickly climbed both the charts in the world of Country and Pop. Her MySpace presence was also a key part of her success, with Taylor directly communicating with her fans on the OG social media platform, making them feel as though they were a part of her journey to stardom. Her outfits would also reflect this humility in those early days of her career. Cowboy boots were often a go-to for both red carpets and on-stage performances. Paired with cami minidresses and ringlet curls, these ensembles slowly began to incorporate more eye-catching pieces that leaned into a playful pop princess approach. Considering Taylor was a mere 17, this demonstrated her evolution into a global performer and teen sensation having the time of her life before our very eyes.

Taylor wearing one of her earlier trademark-style pairings of a boho sundress and cowboy boots as she performs in Kansas City in May 2007.

Fearless (2008)

By the time of *Fearless*, her second studio album, launching in 2008, Swift's presentation was becoming more representative of the stardom she was rapidly gaining. The red-carpet invites were flooding in and her confidence in front of the camera was growing. This sentiment was also reflected in the songwriting on the album, with key themes sitting among fairy tales and romance novels that played out in a way that only a teenage girl's diary could. Metallics seemed to take over the looks with shimmering fabrics and iridescent features aplenty. But arguably the most important style of this era was the introduction of the twenties-inspired flapper minidress that, throughout her ever-changing style, would become a mainstay in the singer's wardrobe for the next decade (and beyond).

Matching with her glimmering dresses that helped to define the aesthetic of the *Fearless* era, many of Swift's make-up looks also focused on gold tones and shimmering shades that complemented the fairy-tale themes of the album. Her lipstick was kept mostly in the realm of baby pinks and soft mauves – but this would all change while on set for the *Allure* photo shoot in New York City, February 2009. Gucci Westman,

In August 2009, Taylor took her *Fearless* tour to New York City, where she wore this shimmering number from Mandalay.

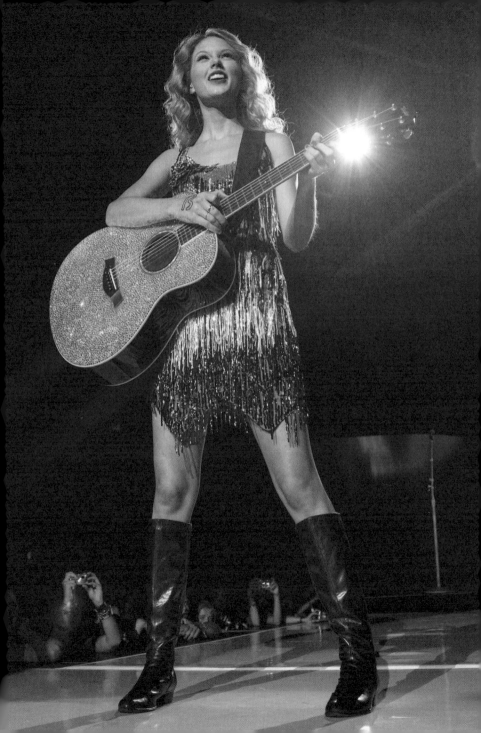

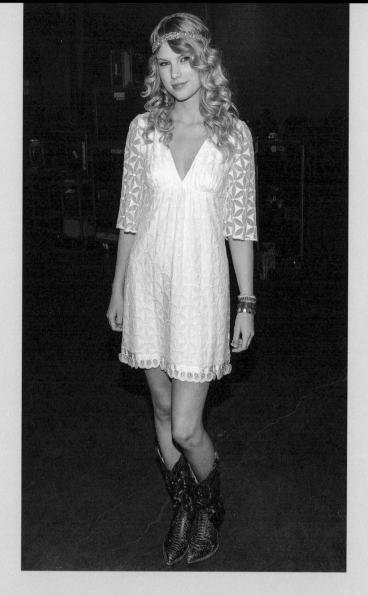

ABOVE Taylor sports a white babydoll dress, metallic cowboy boots and a very of-the-time shimmering headband to the 44th annual Academy of Country Music Awards' Artist of the Decade held at the MGM Grand on April 6, 2009 in Las Vegas, Nevada.

OPPOSITE Attending the 2009 43rd Annual Country Music Awards in Nashville, Taylor wore a strapless gown from Reem Acra's Fall 2009 collection.

celebrity make-up artist and founder of make-up brand Westman Atelier, was on set that day. She recounts her vision for the look being influenced by the Alberto Vargas pin-up girls of the 1940s, adorned with a stark red lip and pale skin. But the suggestion of lip colour was said to be met with some resistance, Westman telling *Insider* in a 2023 interview that the attitude was that Taylor "didn't do red". Westman claims she had to seek the approval of Andrea Swift (Taylor's mum) to use the bold colour. It was a risk that would play a key role in the star's style development and would also go on to influence some of her most iconic songwriting, being referenced in at least seven songs written by her. By September 2009, Taylor would often demonstrate her affinity for the classic shade, even sporting it alongside her head-turning KaufmanFranco dress at the 2009 MTV Music Video Awards (yes, the one when she was interrupted by a certain rapper on stage).

Speak Now (2010)

The *Speak Now* era represents a key moment in Swift's career – not only as a pop star and performer but as an artist in the wider sense. And with that came a wardrobe that saw similar change and growth from her previous looks, which promoted an angelic attitude. The 2010 album was the result of two years of songwriting that she would note as key to her evolution, stating in the notes of the album's 2023 re-release, "I wanted to get better, to challenge myself, and to build on my skills as a writer, an artist, and a performer." With Swift herself referring to the tracks as "unfiltered and potent", the dedication to a more emotional, yet mature approach was also reflected in her fashion choices: sweetheart necklines, Mary Jane heels and

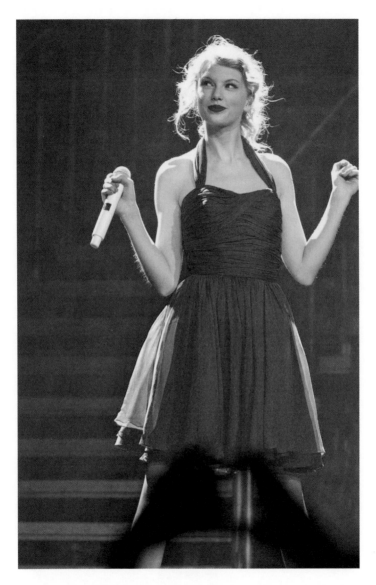

Taylor performed at New York's Madison Square Garden on November 22, 2011. She wore a custom Susan Hilferty dress with a sweetheart neckline and her hair was styled in a bouncy ponytail for a portion of the show.

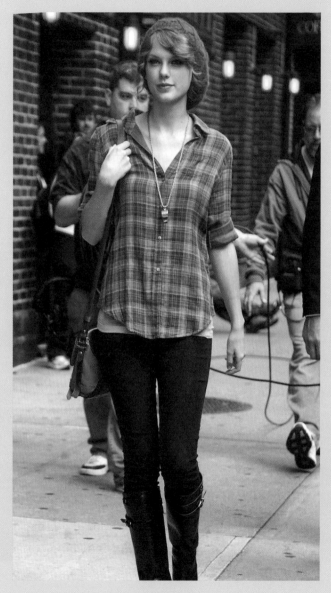

Taylor wore a plaid top from Anthropologie alongside knee-high leather boots, a slouchy beanie and a Ralph Lauren saddle bag for a visit to *The Late Show With David Letterman* at the Ed Sullivan Theater, New York City, on October 26, 2010.

that famous scarlet lip came out to tell the world that the young star was growing up.

Lilac and bright violet played a key role in defining the look of the *Speak Now* era, with Taylor opting for a strapless purple chiffon gown by Lebanese designer Reem Acra for the cover shot of the 2010 album release. The re-released version of the album, released in July 2023, would also feature a Reem Acra design, this time in a lighter shade. A key piece of Taylor's *Speak Now* 2010 tour wardrobe would be a custom Susan Hilferty halterneck dress that quickly inspired dupes from countless high street brands for Swifties across the globe to cosplay as the big TS herself.

This was the perfect time for Swift to call in the experts when it came to her wardrobe. Though she has always been a fan of dressing up and crafting looks that help her express herself, her stage was becoming bigger by the minute and she needed someone to introduce her to new designers and help shape her image to match the one she envisioned was critical to her success in the spotlight. That's where Joseph Cassell Falconer came in. The Nashville native joined Team Swift ahead of her *Speak Now* tour, working with the then 21-year-old star on many of her most iconic looks for decades to come, including the majority of her red carpet looks and headline making on-stage tour outfits. In a 2013 interview with the *Hollywood Reporter*, Swift recalled their first meeting, saying, "Joseph arrived with a full wardrobe of options and shoes, which was a good thing because the stylist at the shoot had dropped the ball. [...] He's always two steps ahead of me with whatever I need, whether it's a lint roller, sunglasses, shoes [...] And he has a backup option and extra panels of material just to be safe!"

"I'm not going to sit there and say, 'Oh, I wish I hadn't had **corkscrew-curly hair** and worn **cowboy boots** and **sundresses** to awards shows when I was 17;

I wish I hadn't gone through that fairy-tale phase where I just wanted to wear **princess dresses** *to awards shows every single time.' Because I made those choices. I did that. It was part of me* **growing up.**"

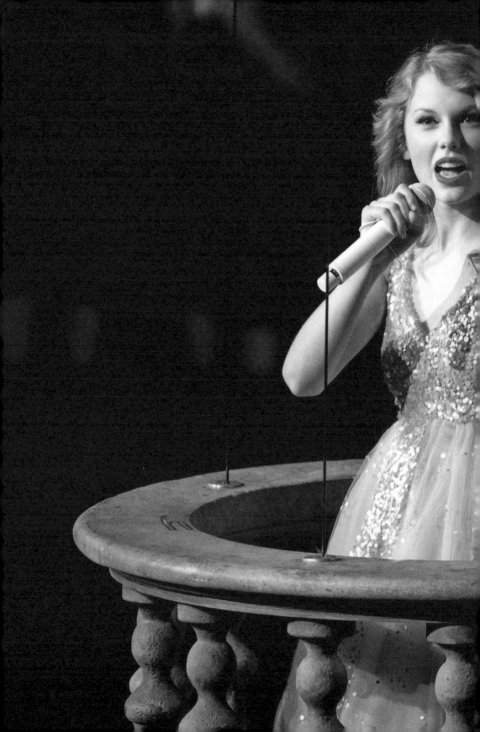

ꟻierce femininity

Red (2012)

One of the most stylistically recognized eras for Swift came in the way of the *Red* era. Accompanying the album that brought us "22" and "We Are Never Ever Getting Back Together", the *Red* look is defined by heavy vintage influences combined with a stark colour palette of scarlet red, crisp white and timeless black. This would also mark a pivotal era for Swift bringing "Tumblr style" into the spotlight, defined by the "hipster" fashion that permeated the decade-defining blog platform. Bowler hats, graphic tees, the coveted high-waisted shorts and crop-top combo that many fashion bloggers at the time would sport proudly in their selfies. And, of course, there were the sunglasses. Heart-shaped sunglasses became a Swiftie favourite after the star sported them in the music video for "22", alongside the classic Ray-Ban Wayfarers style. She'd make the latter a true staple in her accessories rotation for the next decade and beyond by often sporting them as a part of her off-duty looks. And then, of course, there's the bright red lip – the *Red* era's biggest calling card. Though we know Taylor started her love affair with the make-up must-have a few

OPPOSITE Jenny Packham provided Taylor with this floral gown for the singer-songwriter's November 2012 appearance at the 46th Annual Country Music Association (CMA) Awards in Nashville, Tennessee.

OVERLEAF Though many will recognize this on-stage style from Taylor's *Red* tour, she initially wore the Marina Toybina custom ensemble while performing at the MTV Europe Music Video Awards on November 11, 2012.

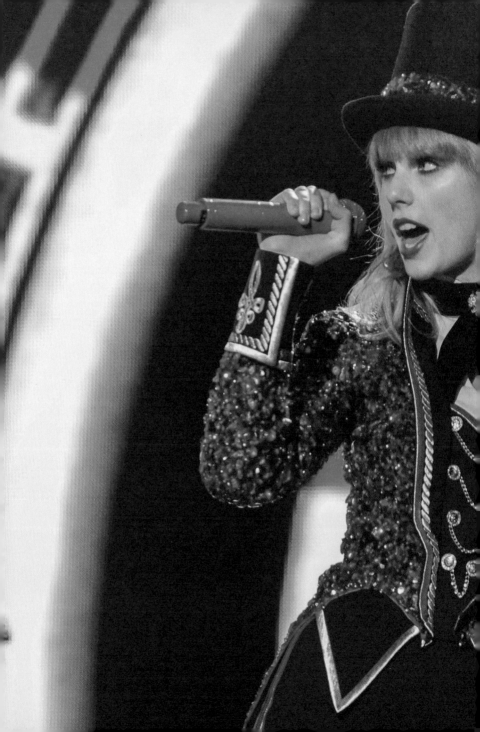

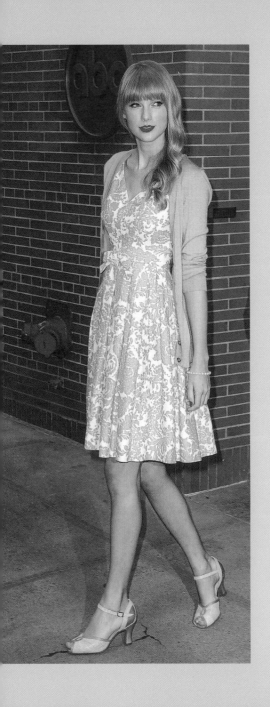

"I'll go through different phases with make-up and always try new things. Except I never really get too far from red lipstick, do I?"

Taylor sports a vintage-inspired floral dress as she heads out in New York City on October 22, 2012.

years earlier, many would come to associate the look with the *Red* era as it became an essential staple for nearly all of her looks at the time. Lorrie Turk, Taylor's long-time make-up guru, has been notoriously quiet when it comes to sharing specific products she uses on the star, but has shared a few of her favourite red lipsticks: MAC's Ruby Woo, NARS Velvet Matte Lip Pencil in Dragon Girl and CoverGirl's Exhibitionist Cream Lipstick in Hot.

The *Red* era would also prove the power of Swift's hairdos in cementing the images associated with her albums. Though she's flirted with a fringe a few times before, *Red* saw Swift commit to the look and say goodbye to the flowing, sun-soaked curls, instead opting for blunt bangs and subtle waves in a soft ash-blonde tone. The story goes that she took the plunge while on the set of a shoot for *Vogue* magazine with celebrated photographer Mario Testino the day before her 22nd birthday. When discussing the change in a video showcasing behind the scenes of the shoot, Swift explained that they were trying to mimic the fringe with extensions before she said, "You know what, just cut it. This is *Vogue*, why not? So I have bangs now."

Taylor kicked off the *Red* era with a performance in a red striped top and black high-waisted shorts at the 2012 MTV Video Music Awards on September 6, 2012 in Los Angeles, California.

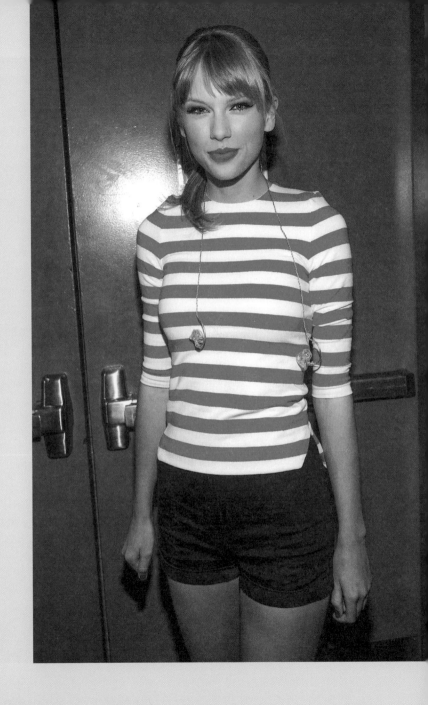

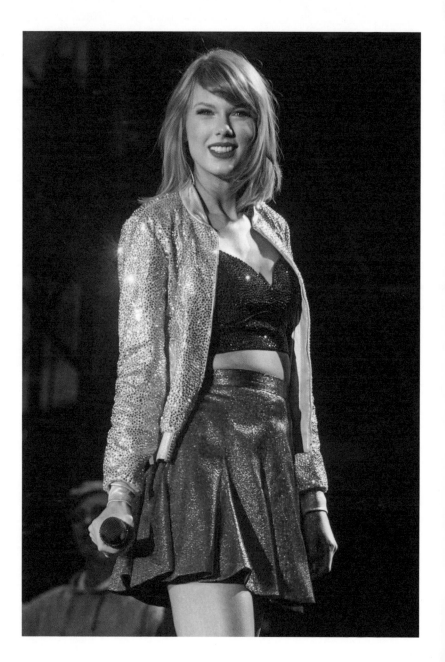

1989 (2014)

The 1989 era marked a time of refined, yet playful looks.
Clean cuts, crisp colours and sky-high heels defined
the period, while Taylor's blunt bob added an element
of maturity. This was also the time that saw a new rise
in the It-girl obsession with stars like Gigi Hadid, Cara
Delevingne, Karlie Kloss and Lily Aldridge becoming some
of the most admired women in the world. They brought
along with them a unique combination of striking styles
paired with a devil-may-care attitude that was not easy to
pull off. Taylor's 1989-era looks proved she could do the
off-duty model look even better than, well, the stars of the
catwalk themselves. By 2015, she would be winning awards
for more than just her music and receive titles such as
ELLE Style's Woman of the Year. The publication would
praise her in an online article for her talent for "seamlessly
switching between chic street style and glamorous couture
gowns on the red carpet."

The *1989* tour saw a range of sparkling bomber jacket and skirt
combos by Jessica Jones, including this one pictured during a
performance on June 6, 2015 in Pittsburgh, Pennsylvania.

"There's something about New York that makes me want to dress nicely."

Taylor sported a Zara top, River Island shorts and baby blue Pedro Garcia pumps as she ventured out in New York City's West Village on May 26, 2015.

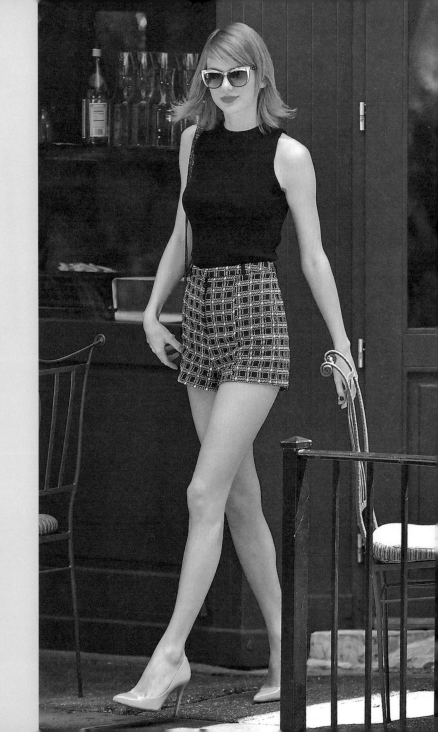

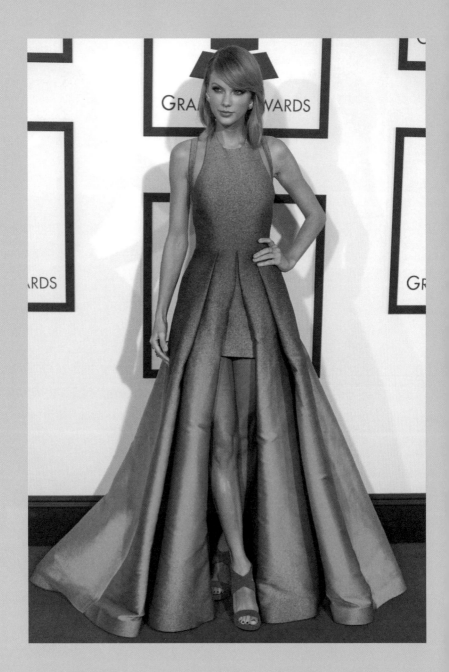

This was also a period when Taylor was making more public appearances than ever before. Her Instagram and Twitter accounts were also a key outlet for the singer-songwriter to shape her image and build relationships with her fans across the globe. But with this growing stardom, the 1989 era would also become a time when she became a target for tabloids and fellow A-listers to share criticisms and get the rumour mill turning on what Taylor was like behind the scenes. Rather than panic amid the pressure to defend herself, she took the time to step back and prepare to tell her side of the story – and this time it wouldn't be through press statements but in a way that no one could ignore.

Fashion editor Halie LeSavage shared in a 2017 *Glamour* piece, "1989 marked her greatest style shift pre-*reputation*: Suddenly, Swift lived in New York and was all about bedazzled bodysuits and revealing cut-outs. Even with her new arsenal of sparkly 'pop star' costumes, Taylor Swift was still Taylor Swift— however, she was at the height of her career, and she had the superstar wardrobe to match it. [...] Luxury—whether it be in one of these gowns or a star-studded group of friends appearing at her concerts—became an integral part of her image alongside the hallmark revealing lyrics of her songs."

In February 2015, Taylor graced the red carpet of the 57th Annual Grammy Awards in a stunning Elie Saab dress with a metallic finish and magenta Giuseppe Zanotti heels.

"*I love how it [fashion] can mark the* passage of time. *It's similar to my songs in that way*–

it all helps
identify *where I*
was at in *different*
points *of my life"*

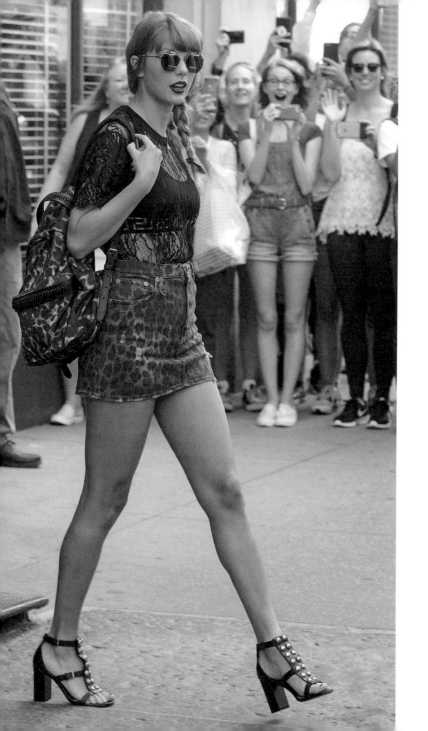

reputation (2017)

The scrutiny that Taylor faced in the media over her career came to a boiling point around 2016 when the Kanye West/ Kim K drama was at an all-time high. The rapper and his then-wife launched something of a campaign against Swift by leaking a call with the star that implied Swift had agreed to Mr West releasing a song that spoke about Swift in a less-than-positive light (something that Swift later denied in an Instagram post). Many began to speculate that the image she'd been portraying of a sweet Southern-gal-turned-pop-icon wasn't an accurate representation of the 26-year-old and regarded her as an open target for bullying and harassment. The symbol of a snake was often used by those who saw her as dishonest in various capacities. This was likely what led Swift to retreat from the public eye in a way that had fans speculating on what her next move would be. Shedding her playful and fancy-free feminine looks, Taylor debuted a darker and more confrontational image with the release of the single "Look What You Made Me Do" on August 24, 2017. The accompanying video saw her sporting outfits crafted from leather, adorned with metal spikes and her famous cherry red lipstick swapped out for a rich crimson shade. The tone was undeniably darker and referenced the ongoing critics by incorporating snake motifs in the artwork for the video, her accompanying tour wardrobe and even as an accessory to her microphone at various live performances around this time.

Taylor leaves her New York apartment in July 2018 wearing Fendi sunglasses, a lacey IRO Paris top, Versace bra and camo skirt from R13.

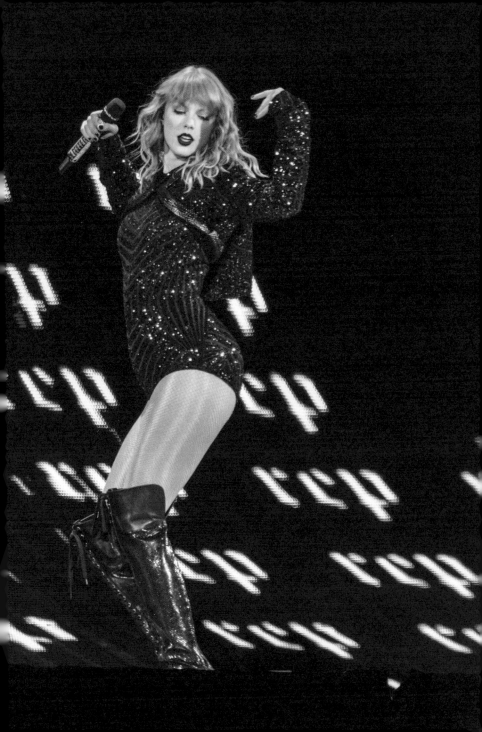

Alongside stepping back from social media (this was the year when she famously wiped her Instagram and Twitter accounts for a fresh start), Taylor also steered clear of many public events during this time in stark contrast to previous years when she was one of the most photographed celebrities in the world. Spottings of the singer by the paparazzi were few and far between (in fact, the number of sightings across 2017–18 is reputed to have totalled just five). When Taylor did step out, her outfits fused a new-found dark dramatic theme with her famous girl-next-door energy. One of her key off-duty looks included a denim leopard-print skirt and lacey tee combo, finished off with a leopard print Stella McCartney bag. On the other side of the spectrum, she proudly sported a stunning pink Versace gown to the 2018 Billboard Music Awards, an event that marked her first public appearance in nearly two years. The *reputation* era was truly one of the most, if not *the* most, dramatic era for Taylor when it came to both music and fashion. Many speculated that this would be the road that the star would continue down and, in turn, completely change her career. But true Swifties know that that's not quite how Ms Swift does things – and there was even more reinvention to come.

PREVIOUS The *reputation* tour bodysuits by Jessica Jones, like the one pictured here in July 2018 in New Jersey, are some of the favourite on-stage styles among Taylor's fans.

OPPOSITE Taylor makes a surprise appearance at the 2018 Billboard Music Awards in May 2018, wearing a pink Versace gown with handcrafted Hueb earrings and shoes by Casadei.

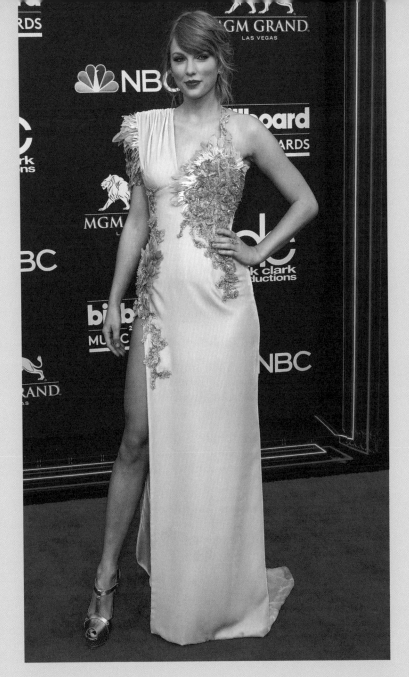

Lover (2019)

While *reputation* hit back at criticism with a heavier fist, Taylor's next album, *Lover*, expressed a more optimistic tone of coming to terms with who she was as a public figure and the acceptance that, regardless of her actions, there would always be a group of people who wouldn't be fans. In a TikTok LIVE, Swift described the album as originating from an "open, free, romantic, whimsical place". And we can see her wardrobe very much followed suit. "You Need to Calm Down" was the first single off the album and directly addressed the backlash she felt after standing up as an ally of the LGBTQI+ community. The colour palette of her *Lover* tour wardrobe played with pastels and sun-soaked rainbows alongside motifs such as butterflies and kittens that communicated a dedication to embracing joy and the little things in life. Oh, and of course, there were sequins and sparkles. And lots of them.

On April 23, 2019, Taylor attended the TIME100 Gala in New York wearing a pastel pink and yellow gown by J. Mendel and jewellery by Lorraine Schwartz.

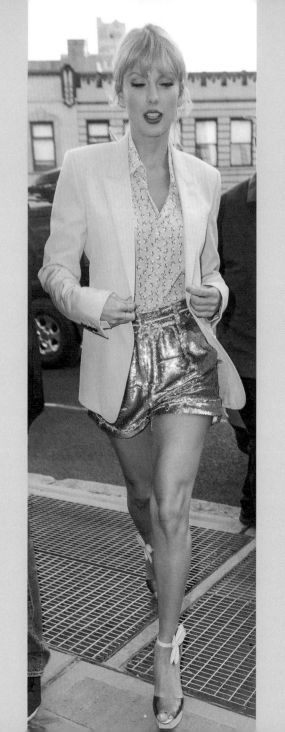

Alongside the album, the singer also released a clothing line designed in collaboration with British fashion designer, Stella McCartney. After the two formed a friendship during Taylor's time in London, they decided to bring the mood board of the album to life with a limited-edition collection of hoodies, sweatshirts, tees and even a bomber jacket – many adorned with Taylor's lyrics or a logo representing the creative duo.

Stylistically, the *Lover* era has proved to be a favourite for pastel-loving Swifties, becoming instantly recognizable for its baby blue and pink hues. In an exclusive interview with the *Independent*, Swift shared her inspiration for the album's aesthetic, sharing, "I wanted it to be like the sky looks after a storm. Colourful, calm, somehow more beautiful than it ever had been before." Beyond the tie-dye-heavy wardrobe embraced by fans around the world, the make-up looks have become iconic with Swifties. Glitter shaped into a heart outline worn around the right eye is an instantly recognizable symbol of fans of the album/era in the audience of Taylor's sell-out stadium shows.

Taylor wore a YSL pink blazer and print shirt alongside IRO Paris sequin shorts as she arrived at the Stonewall Inn for a Pride party performance in June 2019.

"*Swift traded her snakes and hard edges for butterflies and hues of pastel, a symbol for the way she's choosing to* **brand herself as a lover** *rather than a fighter.*"

HANNAH ANGELL, THE *SPECTATOR*

Taylor accepts the Artist of the Year award at the 2019 American Music Awards on November 24, 2019, wearing a custom cape by her stylist, Joseph Cassell and bodysuit by Jessica Jones.

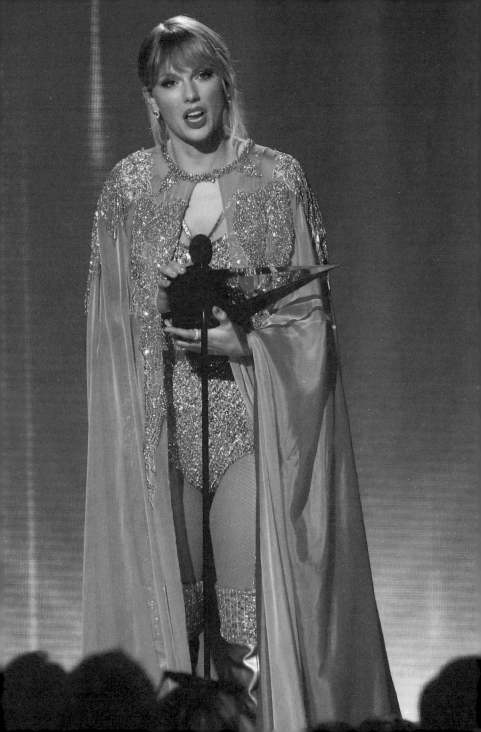

The queen of cottagecore

folklore/evermore (2020)

It wasn't just the release of *folklore* in July 2020 that took the public by surprise but the style, sound and associated imagery of the album. Appearing more like something from a seventies folk singer than a billionaire pop star, the album release prompted a distinct new chapter for Taylor – one that was undeniably atmospheric and cosier than ever before. This would mark a shift toward a stronger focus on the artistic element of her career, confirmed by collaborations with indie songwriters including Aaron Dessner of The National and Bon Iver's Justin Vernon.

Whereas her previous album, *Lover*, saw bright colours, playful shapes and iconography, *folklore* was full of monochrome and soft shades mimicking vintage photographs. Swift's outfits followed the same down-tempo note. British *Vogue* contributor Rosalind Jana referred to the aesthetic as "Grainy woodland scenes featuring Swift clad in check, lace, loose layers and snug sweaters felt not just atmospheric, but intensely suited to this moment: one in which we have been seeking the twin salves of comfort and escapism."

Attending the 55th Annual Academy of Country Music Awards in September 2020, Taylor wears head-to-toe Stella McCartney.

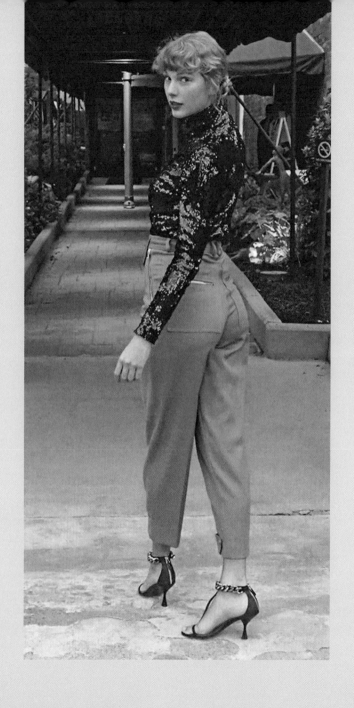

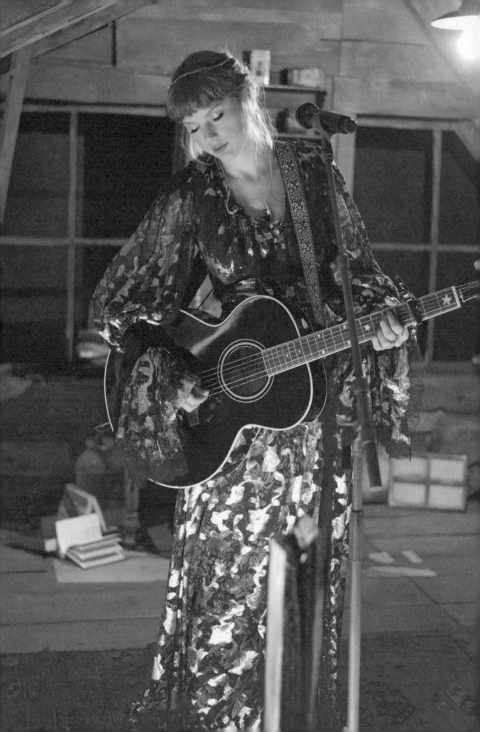

As much of the world came to a standstill, Taylor showed her reflective side by channelling styles reminiscent of humble small-town America. Cardigans, corduroy, gingham prints and muslin ruffles came alive in the *evermore* and *folklore* era. Taylor showed the world that despite the glitz and glamour that the singer displayed over much of her tenure as one of the most influential women in the world, she was also a twenty-something woman who wasn't afraid to slow down and get cosy as much of the world did at the time. Though keen to emphasize vintage pieces, brands like Free People, Magnolia Pearl and, of course, Stella McCartney also helped shape the *folklore* aesthetic of warm hues, familiar textures and heritage-inspired silhouettes.

Boiled down, Taylor's *folklore/evermore* era is a calling card for Cottagecore. But it's worth noting that the genre/aesthetic/ trend/religion predates her affinity with it. In July 2020, *W Magazine* published a piece online entitled "Taylor Swift Has Discovered Cottagecore", in which writer Kyle Munzenrieder summarized the phenomenon by saying, "Cottagecore is an aesthetic that has been bumping around Tumblr dashes and Pinterest boards for a while now, but has found new relevance thanks to both lockdown and its resurgence on TikTok. The feel is pretty explanatory: imagine a romanticized life living in a cabin in the middle of a forested nowhere. Think hikes in the woods; flowing, feminine clothing; freshly homemade bread; needlepoint kits, and writing a letter by a fire while drinking a warm beverage from a tea set." Bands like The National and indie artist Bon Iver had been established as

Taylor performs at the 2021 Grammys wearing a flowing Etro gown, custom-made for the star.

kings of the scene for years ahead of the *folklore/evermore* releases, making them a natural choice of collaborators for the album.

evermore quickly followed *folklore*, hitting the shelves just five months later in December 2020. When it comes to the style associated with the album, the nostalgic warmth continues on from *folklore*, with much of the *evermore* press imagery featuring designs from Stella McCartney, including the check jacket on the album cover (which would go on to become a Swifties' favourite to mimic).

Taylor's beauty routine was also a pared-down approach during this time, allowing her natural waves to come through after years of straightening and swapping blunt cuts for natural growth that aligned with the reduced hairstyles available now for much of the population. Previously a lover of ruby red lips and sharp eyeliner styles, her make-up bag also received a bit of a break with minimal cosmetics being used in much of her photos.

The Etro design is displayed at the Power of Women in Country Music Exhibit Press Preview at the GRAMMY Museum on May 26, 2022.

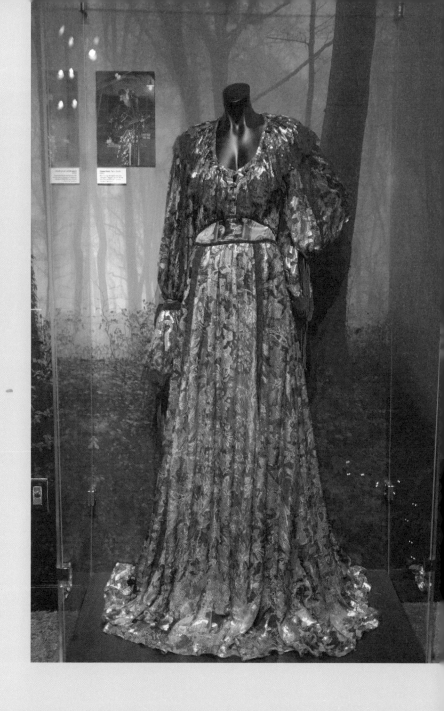

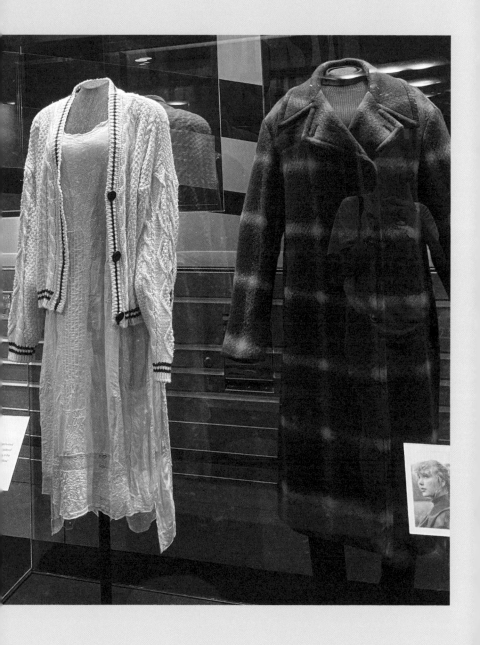

Then as the world began to open up again and Taylor returned to on-air performances, the humble look of knitwear and natural hair translated into styles for the camera that infused the themes into red-carpet-ready looks such as the head-to-toe Stella McCartney outfit she wore (and styled herself) to the 55th Annual ACM Awards in September 2020. The look was made up of a sequin burgundy bodysuit worked with high-waisted tan trousers with a tapered leg and zip details at the pockets and cuffs, complete with a low hair bun and soft make-up. And then there was the floral Oscar de la Renta gown worn to the 2021 Grammys in Los Angeles, accompanied by a subtle nude lip and cute braided updo as she accepted the award for Album of the Year, marking her 11th Grammy win.

OPPOSITE Two key styles from the *folklore/evermore* era sit on display as a part of the Taylor Swift exhibit at the Country Music Hall of Fame Museum in Nashville, Tennessee.

OVERLEAF For the *folklore* section of a number of her 2023 Eras tour dates, Taylor wears this cream Alberta Ferretti design, which features flowy sleeves and crystal embroidery.

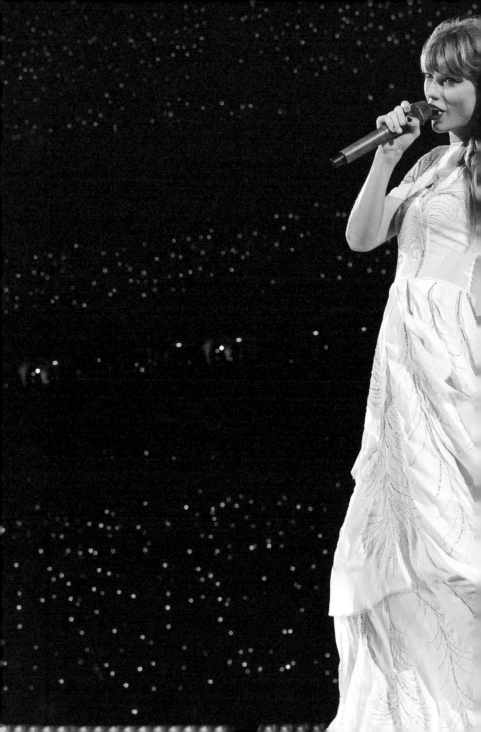

Playful nostalgia

Midnights (2022)

Proving yet again her talent for reinvention, Taylor debuted her 2022 *Midnights* album and hinted toward its accompanying look and feel through an Instagram post on August 29, 2022 with a caption that read, "Midnights, the stories of 13 sleepless nights scattered throughout my life, will be out October 21. Meet me at midnight." The press imagery associated with the release depicted the singer in vintage-inspired knitwear, realized in warm colourways, with simple and pared back hair and make-up. Swifties will also remember her TikTok series, "Midnights Mayhem With Me", a 13-parter in which she introduced fans to each track of the new album. The looks she presented during those TikTok LIVE episodes continued to solidify the seventies-inspired style of the album and included pieces from labels such as Reformation, Chloé and The Row.

Vogue writer Christian Allaire summarized the *Midnights* look, stating in a 2022 feature entitled "Taylor Swift Is Deep In Her Edgy Disco Era", "Swift's style era ahead of her *Midnights* release is a stark contrast to the folksy aesthetic that she channelled for her last two albums, *folklore* and *evermore*, when she wore chunky cardigans and plaid shirts. If her prior wardrobe was all about cozy comfort and quiet nights in, Swift is clearly ready to be seen and hit the town again."

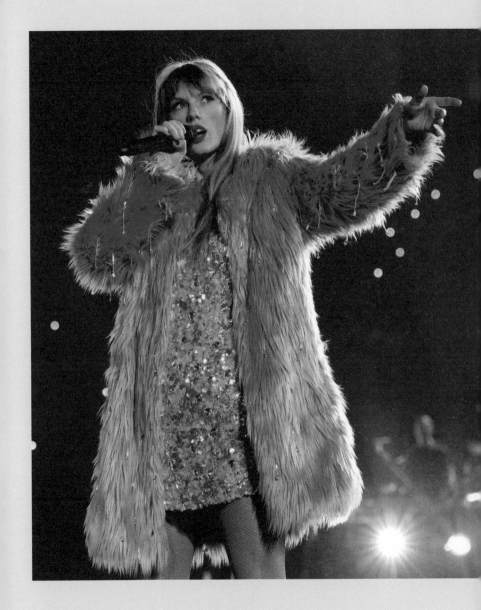

Similar to the faux-fur style worn in the 2022 video for "Lavender Haze", this Oscar de la Renta jacket was worn during the *Midnights* section of Taylor's Eras tour in 2023.

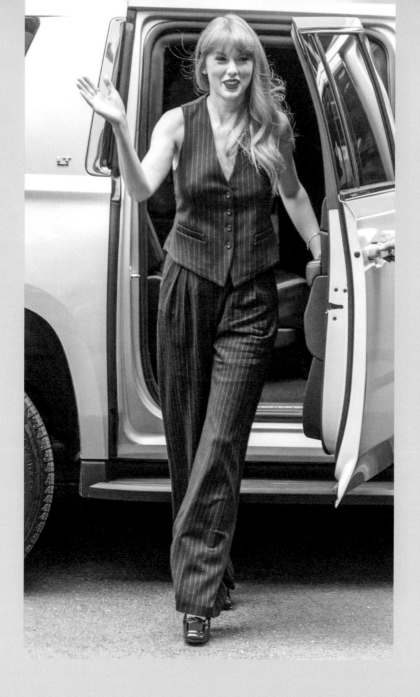

The *Midnights* era saw the red-carpet look of a navy Roberto Cavalli custom design covered in shimmering crystals for the 65th Annual Grammy Awards held in Los Angeles in February 2023. The look showed off her midriff (in possible homage to her *1989* era when she proved her commitment to the crop-top and high-waist bottoms club with many of her looks following the format) and was complemented by statement Lorraine Schwartz earrings featuring 136 carats of natural purple sapphires, diamonds and Paraíba tourmaline gemstones (a rare jewel hailing from Brazil). But when it came to more casual occasions, the *Midnights* looks were kept pretty simple. In June 2022, Taylor attended the Tribeca Festival in New York City wearing a Max Mara look comprised of a pin-striped navy waistcoat and matching wide-leg trousers. Red Prada leather loafer pumps from the Italian fashion house's 2010 collection (yep, a whole 13 years earlier) may have pointed purposefully at the *Speak Now* re-release that would follow a few months later. Or were they just some nice shoes? Only TS herself knows.

Alea Wilkins, writer at *Stitch Magazine*, summarized Taylor's *Midnights* era beautifully, sharing, "As an artist acutely aware of every detail and unafraid of transformation, Swift's new style for her *Midnights* era extends the key messages of the album's lyrics. Her wardrobe—from comfortable clothing worn during her more brooding moments to heavily bejeweled party-wear—captures all the catastrophic feelings that occur after midnight: the melancholy, the madness and the magic."

Taylor arrives at the Beacon Theater in New York City on June 11, 2022, to attend the screening of her short film, *All Too Well*.

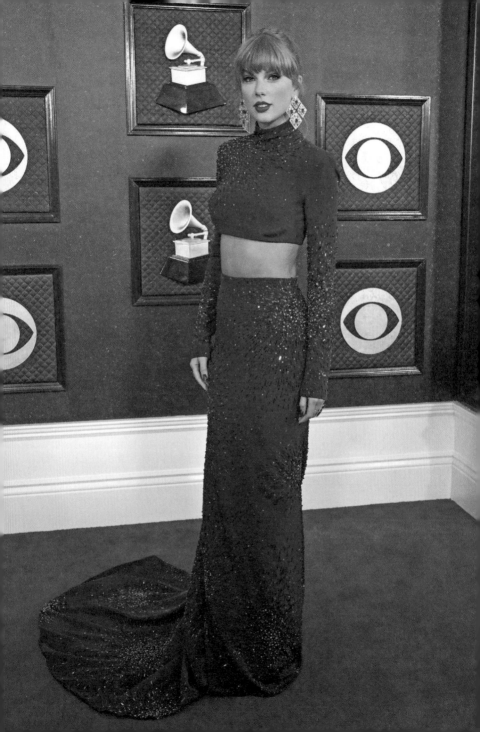

"Swift effortlessly transitions from vintage-inspired looks to contemporary, edgier ensembles— always maintaining an air of sophistication."

CAROLYN MAIR, FASHION PSYCHOLOGIST

Headlines were very much made with Taylor's first red carpet appearance of 2023 at the 65th Grammy Awards, wearing this two-piece style by Roberto Cavalli.

Key

CHAPTER 2

Looks

Whatever outfits Taylor Swift slips into, it seems that the singer-songwriter is bound to make headlines. But among the styles are some that made particular impact not just with those who have a particular love for the star but on the wider zeitgeist and, in the case of some, fashion history. From supporting emerging designers to using her fashion choices to make powerful statements, Taylor is not just a style icon but, as many would agree, a true cultural trailblazer.

In this chapter, we embark on a captivating journey through Swift's most legendary looks over the first few decades of her career. Each outfit tells a unique story and together they form a tapestry of her journey from 15-year-old country sweetheart to thirty-something producer, artist and filmmaker. Here we will delve into the inspirations, collaborations and messages behind each look, and obtain a deeper understanding of the woman behind the fashion icon.

"*Taylor Swift's style* reflects her personal fashion choices *rather than ones that conform to industry trends [...] This* authentic approach *has made her a* style icon *and very relatable figure for her fans, almost like the girl next door— but better.*"

CAROLYN MAIR, FASHION PSYCHOLOGIST

Low-key looks

One of the key traits that has set Taylor apart from other superstars over the years has been how she manages to exude a relatability – so many young women across the world can imagine her seamlessly fitting into their friend groups, discussing books over coffee as they browse the local second-hand shops. This power can partly be credited to the wardrobe pieces she reaches for on those days in between tours and high-profile events. As she heads off to spend time with one of her many close gal pals like Gigi Hadid or Blake Lively, Taylor tends to present herself in clothes that help tell the story that she wants the world to see. She might be an idol for millions but she is also just someone who likes to balance being comfortable and cosy in the colder months, while also being a bit playful and fashion-forward when the occasion allows.

In this first look, we see a young Taylor set out from her hotel in Paris while on her 2011 *Speak Now* tour. The skater skirt and striped top ensemble demonstrate the cutesy casual look that she played with for so many outings early on in her career. The black tights also hint at the innocence of our "TayTay" at the time, hiding the legs that would go on to become a key aspect of her look, rarely having them under wraps for much of her appearances from 2014 onward (giving weight to the rumour she had her stems insured for a cool US $40 million

On March 17, 2011, Taylor stepped out in Paris wearing a stripey top (rumoured to be from Zara) with a black skater skirt, Oxford heels and Ralph Lauren cross-body bag.

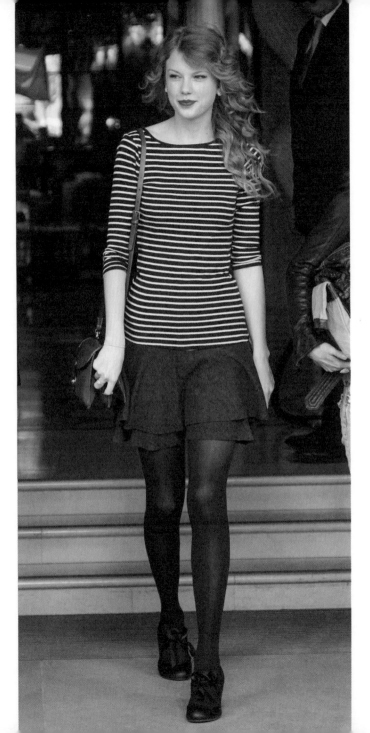

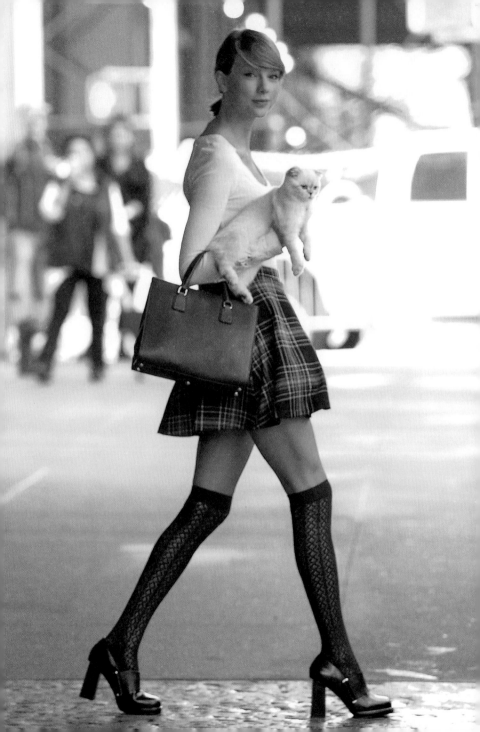

in 2015). And let's not overlook the heeled Oxford shoes that help wrap up this look, a footwear choice that Swift would hold on to for years to come, all while getting some serious flak from fashion critics (an article entitled "Taylor Swift needs to ditch her god-awful shoes" was published online in 2014 by the *NY Post*). But, though she has ultimately left the seemingly divisive shoe style in the past, its extended presence proves the singer's not immune to the odd awkward outfit choice that might not have aged quite so well as a fine wine. However, according to a 2019 piece with *Elle*, titled "30 Things I Learned Before Turning 30", Taylor's very much aware that this is a key part of growth, saying, "Fashion is all about playful experimentation. If you don't look back at pictures of some of your old looks and cringe, you're doing it wrong." Agreed.

By 2014, Taylor's street-style looks had begun taking on a more confident tone with her heels getting higher and designer styles (Dolce & Gabbana and Michael Kors being firm favourites) fast becoming staples in her closet. This look embodies much of her affinity for vintage-inspired pieces that she began to explore with the *Red* album release a couple of years prior in 2012. With her famous feline Olivia Benson on her arm, Taylor wears a plaid skater skirt alongside a simple long-sleeve top from Free People, a long-time favourite label of the star. Thigh-high crochet socks add some warmth on a crisp September day, while the leather pumps and Dolce & Gabbana handbag give a polished finish.

Taylor showed off her feline friend in September 2014, wearing a top from Free People, a plaid RD Style skater skirt, & Other Stories pumps and a bag from Dolce & Gabbana.

In 2015, Taylor decided to grab lunch in West Hollywood with famous bestie Selena Gomez. Little did she know, this would be a pretty iconic outing among her fans – and the press – for a particular leather accessory donned for the occasion. The singer-songwriter wore a graphic sleeveless top, shorts, ankle boots, a studded Louis Vuitton bag and, well ... a leather harness. Instantly the internet took note of the unexpected choice and there were some big question marks across the board. Headlines like "Taylor Swift Wears A Harness, Makes The Internet Explode" and "Taylor Swift Causes Raised Eyebrows As She Steps Out Wearing Leather Harness" popped up across the Web, with many highlighting the close association with BDSM and fetishwear – quite the jump from her usual sundresses or jeans and tee combos often sported on days out.

What stoked the fire even further was many claiming the harness was worn backwards, fuelling the argument that Taylor's pretty pop-star persona wasn't quite conducive to the darker element that the leather accessory portrayed. Though many Swifties confessed to being a bit confused by the choice themselves, they'd be quick to share that the harness was displayed in the same way on the Free People site, where Taylor had obtained it. The singer took the critiques on the chin, issuing a response to the chaos, stating on her Tumblr, "I think you're ignoring a really important point here... That my harness and I are always ready for a zip line/rock climbing. Ask yourself... Are you ready for extreme adventure should it present itself? HARNESS LIFE 2015."

The Free People harness that made headlines, styled here in June 2015 alongside a Rachel Platten top, shorts by James Jeans and studded Louis Vuitton bag.

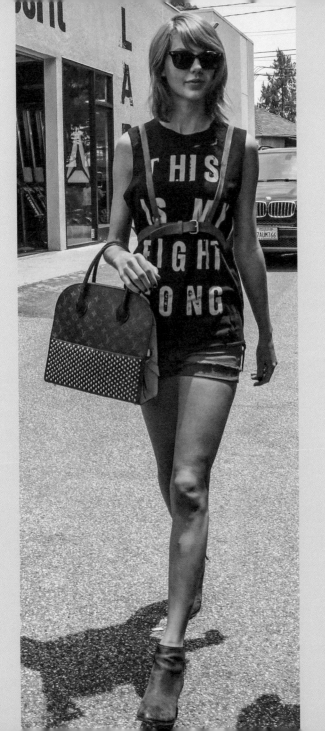

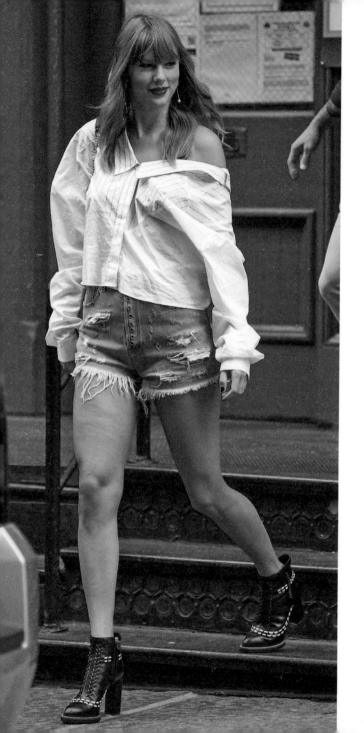

Noted for being featured in *Miss Americana* (2020) (the award-winning documentary on Taylor's life by Lana Wilson) this street-style look made a serious impact with a white shirt by Unravel Project, distressed denim Gucci shorts and leather Tod's boots with white and red stitching. The accessories included a tweed Tommy Hilfiger bag and cat earrings from Miu Miu. "Because if Taylor Swift can be relied upon for anything, it's adorable cat accessories. These ones are at least finished with pearls. Because they're classy cats," read the caption on TaylorSwiftStyle.com, the unofficial mecca for all things related to the star's wardrobe. Aside from a nod to her love for felines, the look also stands as an important one for reminding us of the impact that the overwhelming attention can have on Ms Swift. In *Miss Americana*, Taylor is wearing the outfit as she exits her NYC home, swarmed by screaming fans, and gets into a car, where she shares with the camera, "So this is my front yard. And I'm highly aware of the fact that that is not normal."

In a 2023 street style look, Taylor faces the famous Big Apple heat in a look featuring some of her most treasured labels (with sentimental details, of course). The rose-covered corset top is courtesy of Free People and is worn alongside some classic black denim shorts and slingback loafers from Swift's favourite, Reformation. In the accessories department, we see a Ralph Lauren Rl Clutch, sunglasses courtesy of Stella McCartney and a necklace designed by friend and fellow musician Phoebe Bridgers, made in collaboration with Catbird. Because we all know Taylor's best looks are the ones with sentimental value.

Taylor makes a rare appearance during the *reputation* era in July 2018, wearing a look comprised of Gucci distressed denim shorts and an off-the-shoulder top by Unravel Project.

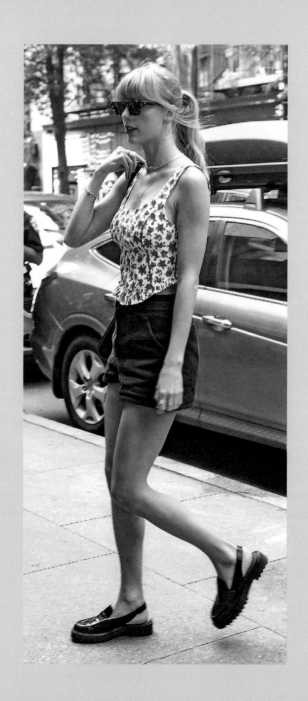

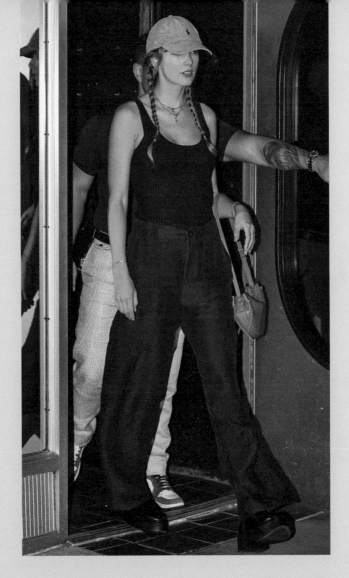

OPPOSITE A floral top from Free People is worn with simple black shorts, Reformation loafers and Stella McCartney sunglasses during an outing in New York, June 2023.

ABOVE In September 2023, Taylor entered her baseball cap era with a Ralph Lauren style completing this look featuring a Gabriela Hearst top, Vince cargo trousers and boots from The Row.

Centre-stage styles

As Taylor Swift's career has grown in both breadth and depth, her on-stage fashion choices too have evolved into more powerful tools in her storytelling and solidify the themes of her tours and albums. From the sparkling Roberto Cavalli dress that became a Swiftie essential during her *Speak Now* tour to the custom Atelier Versace bodysuit that lit up the stage during the Eras tour, the star's centre-stage styles have been some of her most recognizable and iconic looks to date. And it's easy to see why.

One of the first looks to really cement her love for flapper-inspired sparkly minidresses was one particular outfit from her *Speak Now* tour that spanned across 2011 and into 2012. The style designed by Roberto Cavalli would spark countless dupes from high-street labels that continue to be instantly recognizable as a key look for fans of the star. The dress had also been previously spotted on Taylor during a performance on *X Factor* (*Italy*) in October 2010. Type "Taylor Swift dress" into Google and this is the look that is likely to saturate the page. Similar dresses have continued to be worn by Swift throughout the years, with her Eras tour being full of Roberto Cavalli designs, including plenty of fringe looks that complement her movements on-stage. Sketches from creative director Fausto Puglisi, released for these on-stage looks, have been known to arrive accompanied by words

This Roberto Cavalli fringe dress has stood the test of time, with one of its first sightings being on Taylor's *Speak Now* tour in 2011.

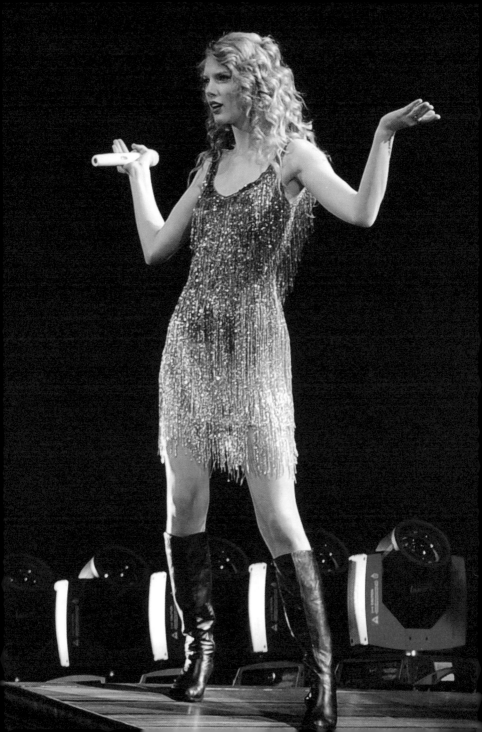

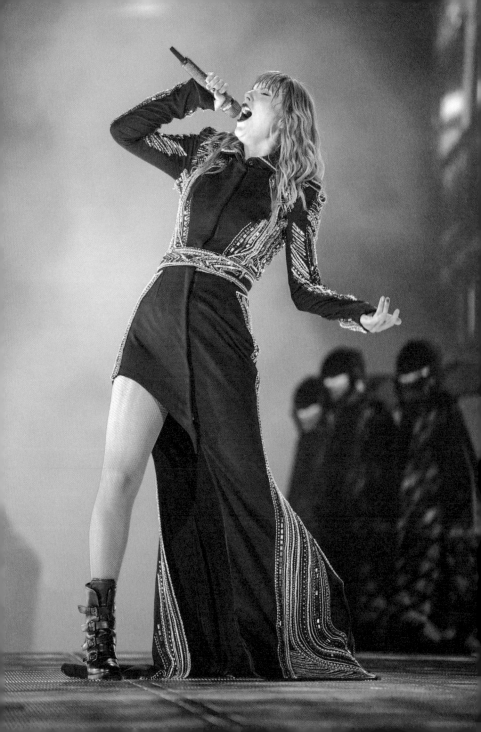

of admiration for the songstress such as "Queen of the Universe!", highlighting the strength of their relationship. Cavalli would also be the name behind plenty of the looks on the Eras tour, including a number very much inspired by this style, worn during the *Speak Now* portion of the performance. In a March 2023 piece with British *Vogue*, Puglisi shared the label's approach, stating, "We took an artisanal approach to craftsmanship – when you create for a concert in a stadium with so many people, everything must be eye-catching." Though the design first saw popularity long before Ms Swift was born, the fringed minidress saw spikes in popularity correlating with the global tour when high-street labels like Jaded Rose, ASOS and River Island all lined their respective shelves with dupes of the look.

One of the eight outfits worn as part of her record-breaking *reputation* tour made a clear impression on fans – a custom style credited to LA-based Jessica Jones. The designer first worked with Swift on the costumes for the 2014 "Bad Blood" video and has gone on to collaborate on various tours including the 1989 tour and the ground-breaking Eras tour. The long-sleeve number, worn during performances of "Don't Blame Me" and "Long Live/New Year's Day", featured gold and silver-tone beading that shimmered in the stage lights. Footwear for the tour was provided by French fashion designer Christian Louboutin, with the Glorymount Studded Buckle Boot being worn with this particular look. By the time the Eras tour came around in 2023, the peek-a-boo leg look had become a fan favourite with the *reputation*

Taylor dons a Jessica Jones custom gown and Christian Louboutin boots on her record-breaking 2018 *reputation* tour, pictured here in Toronto, Canada.

era represented by a similar look, again designed by Jessica Jones. This time it featured a serpent-inspired sequin design spanning the length of the garment. "It's sexy, it's iconic, and it perfectly embodies the 'reputation' aesthetic—so much so that it outdoes every outfit she wore on the reputation Stadium Tour by a mile," wrote Courteney Larocca, entertainment editor at Insider.com, in an online piece in October 2023.

In November 2019, Ms Swift delighted fans by performing a medley of six of her hits at the American Music Awards in Los Angeles. This performance would be especially critical as the singer was in the midst of a public battle with former manager Scooter Braun and Big Machine Records over the rights to her first six albums. There was talk that if the parties couldn't reach an agreement, Swift might not be able to perform her music at the awards show. Thankfully it seems a deal was struck and Taylor was able to perform – and perform she did. She started the show by belting some very fitting lyrics from her recent single, "The Man" (which notably remarks on the patriarchy) from her 2019 album, *Lover*, wearing an oversized white shirt with block text of the titles of the albums she was battling over ownership. With the hints toward the lawsuit flying, Taylor then shed the shirt to reveal an on-brand golden bodysuit and matching ankle boots as she danced with fellow artists, Halsey and Camila Cabello. Though worn for mere minutes, Taylor must have known the white shirt made quite the impression, releasing a long-sleeve cotton tee version of the design as official Taylor Swift merchandise on her online shop the next day. Crowds of the Eras tour confirmed the status of the look, with many fans recreating it for themselves or donning one of the many renditions sold on Etsy.

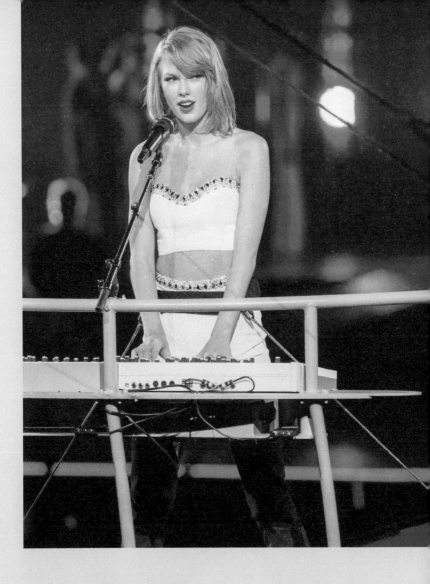

ABOVE The *1989* era saw an array of two-piece outfits including this one from Jessica Jones with gemstone detailing and thigh-high Stuart Weitzman boots.

OVERLEAF A Lorena Sarbu crop top and shorts combo, worn here at the MTV Video Music Awards in August 2014.

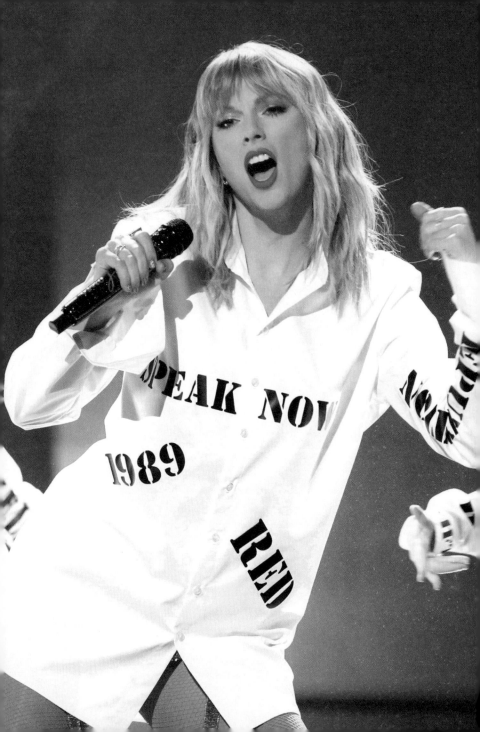

On November 24, 2019, Taylor performed at the American Music Awards, sporting a white shirt covered in the names of the previous albums that were then being fought over for ownership with Swift's former manager, Scooter Braun. The prison letter font prompted *W Magazine*'s Culture Editor, Brooke Marine, to speculate: "The message: Swift, apparently, is now an inmate of the music industry."

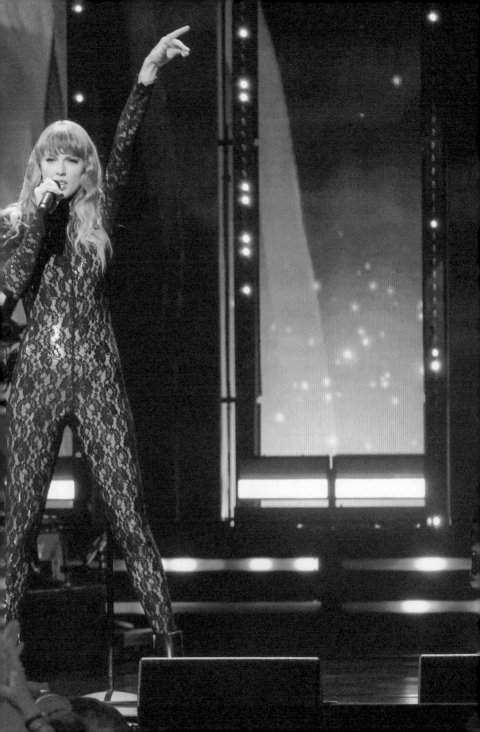

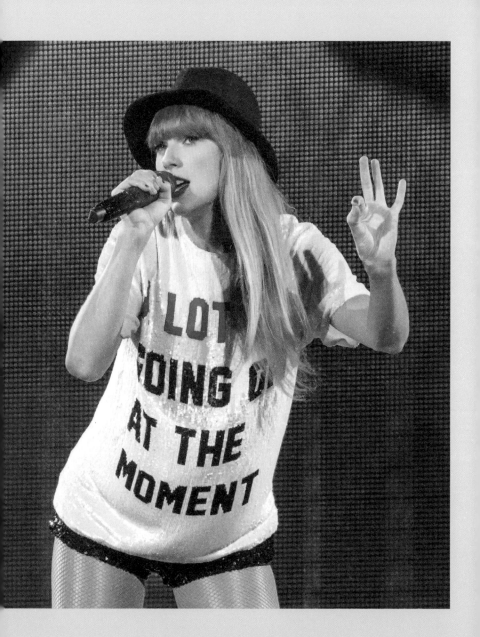

"It's clear that for Swift her onstage outfits are as much a part of telling her story as the music itself."

ANNA TINGLEY, WRITER

PREVIOUS Taylor performs during Carole King's Rock & Roll Hall of Fame Induction event wearing a lace catsuit by Sarah Regensburger on top of a gold lamé bodysuit by Greta Constantine on October 30, 2021, in Cleveland, Ohio.

OPPOSITE For the *Red* section of her Eras tour, Taylor wore a custom sequin tee by Ashish Gupta and Gladys Tamez hat, pictured here on July 28, 2023 in Santa Clara, California.

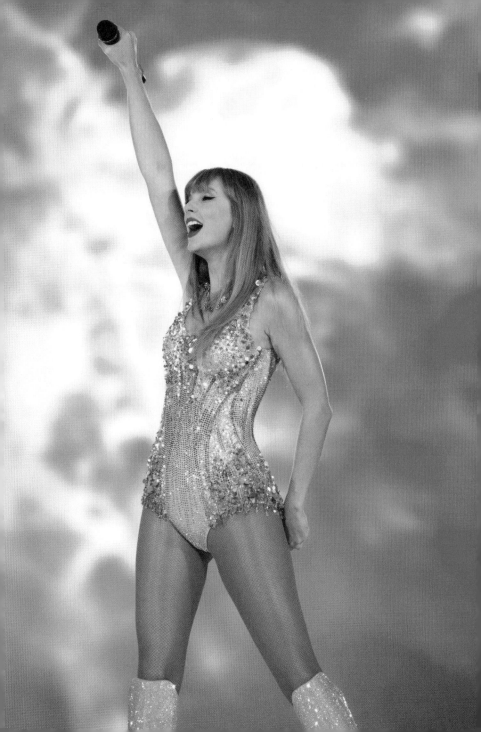

The Eras tour will undeniably go down in history as having some of the most iconic outfits of Taylor's career. Sold-out stadiums across the world were treated to an array of dazzling styles that represented each of her past albums – from Roberto Cavalli fringe minidresses to honour the *Fearless* era to larger-than-life ballgowns from Nicole + Felicia for *Speak Now*. But one of the key looks that will be forever associated with the global arena tour is undoubtedly the custom Atelier Versace bodysuit donned by Ms Swift for the *Lover* section of many of her shows. The style features all-over jewels and sequins in pastel pink and blue hues (there was also a gold and blue version that made a few appearances). As the tour went on, a few variations were introduced, some featuring added fringe details, but the foundation remained the same.

Donatella Versace took to Instagram to show her love for Taylor and the bodysuit, sharing, "you are breathtaking in Versace. I'm so proud of you. Best of luck on The Eras Tour." The look was worn with knee-high Christian Louboutin boots, custom-made for the tour, complete with shimmering crystals and the famous red soles.

OPPOSITE Versace provided Taylor with the instantly iconic bodysuits for the *Lover* era section of her Eras tour, pictured here on July 28, 2023 in Santa Clara, California.

OVERLEAF Another style from her July 2023 Eras tour performance in Santa Clara, California. Here Taylor stuns the crowd with this Nicole + Felicia Couture custom gown, worn during the *Speak Now* section.

High-fashion moments

The red carpet can often be the setting for make-or-break moments in the careers of young artists. For Taylor, these star-studded events would also be key in communicating with her fans through various eye-catching designs in ways that she couldn't with her street-style looks. These looks would help her gain respect from fashion critics far and wide, including *Vogue*'s very own Anna Wintour. Here, we explore some of the high-fashion moments that defined her style evolution.

Marking her second appearance at the MTV Video Music Awards, Taylor's 2009 appearance would go down in the history books as one of the most memorable moments the award show circuit had seen across the '00s. She arrived on the red carpet wearing a glitzy gown from KaufmanFranco, the label from Ken Kaufman and Isaac Franco. In a 2017 interview with the *Huffington Post*, the designer pair shared their thoughts on Taylor, saying, "She's got a beautiful voice and she's talented. Like, hello, an amazing woman wants to wear our clothes? We're like, 'I'm sorry, we love you!'"

On September 13, 2009, Taylor rocked a shimmering style from Kaufman Franco Resort 2009 to the MTV Music Video Awards at Radio Hall, New York City.

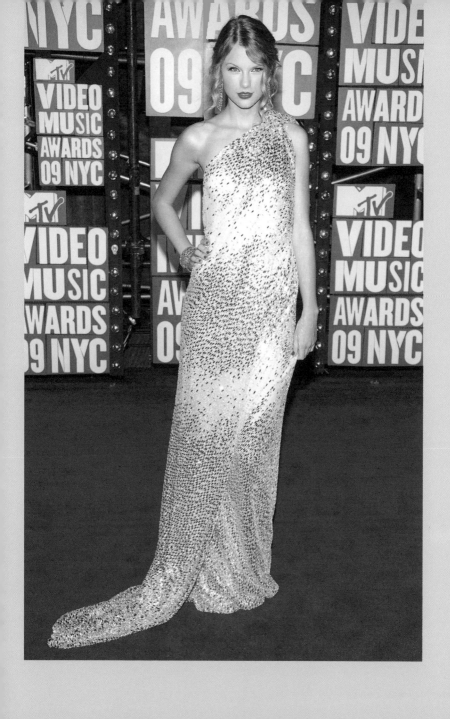

The one-shoulder design from the KaufmanFranco Resort 2009 collection was to appear in countless print and online publications alike after rapper Kanye West interrupted the moment when Taylor was receiving her award for Best Female Music Video for her hit "You Belong with Me". Kanye's unscripted moment was to share his views that Beyoncé should have won the award, not Taylor. The message left the world confused and many angry that Taylor's big moment was interrupted and overshadowed by this outburst. The incident would go on to inspire countless references in pop culture for the next decade or so, including Taylor's performance at the following year's MTV Video Music Awards when she performed her song "Innocent" with clips from the viral moment from the year before playing behind her. Various lines in the song are rumoured to be in reference to Kanye, notably "Thirty-two and still growing up now" and "Who you are is not what you did. You're still an innocent."

On May 5, 2014, Taylor stepped out in a gown that she'd go on to refer to as "the most beautiful dress [I] ever wore" in an interview with *Vogue* a few months later. The Met Gala outfit consisted of a flowing custom-made Oscar de la Renta dress, Christian Louboutin heels and a clutch by American label, Edie Parker. The event marked a key "pinch me" moment for Taylor, stating, "Oscar de la Renta is the designer I've idolized since I was a little girl [...] Having an opportunity to wear a one-of-a-kind gown designed by him is a daydream realized." The stunning pink floor-length gown featured gold sequins and pearl and silver-tone beading alongside metallic

threadwork leaves and petal embroidery. But the stunning garment nearly didn't make it, following an incident with one of Taylor's beloved felines. "That moment when your cat casually walks up, then abruptly ATTACKS your custom satin Oscar de la Renta gown during your fitting for Met Ball," Taylor tweeted earlier in the day. The accompanying jewellery was kept quite simple (by red-carpet standards anyway!) with two vintage-inspired rings and a pair of pink diamond earrings that poked out from her wavy bob – all provided by Lorraine Schwartz. The gown would prove to be a powerful symbol of a particularly innocent era of TS's life, having been featured in the music video of "Look What You Made Me Do" as worn by the "old Taylor" before quickly cutting to today's star in a bathtub of jewels.

Taylor's 2016 Grammys' outfit can easily be dubbed as one of her most memorable and admired red-carpet looks to date. The Versace design featured an orange bandeau top and a voluminous pink skirt with a bold slit. Swift's blunt bob and red lip gave this outfit additional impact, inspiring a review from *Bustle*'s Emily Lackey, calling the look "color-blocking brilliance" and "hands down, a perfect look". Making an appearance with Selena Gomez on her arm as her platonic date for the evening, that night Taylor won the award for Album of the Year – the only woman in history to win the title twice. Addressing the audience, she shared, "As the first woman to win Album of the Year twice, I want to say to all the young women out there, there are going to be people along the way who try to undercut your success or take credit

OVERLEAF Taylor confirmed her spot as a fashion icon with this soft pink Oscar de la Renta gown at the 2014 Met Gala in New York.

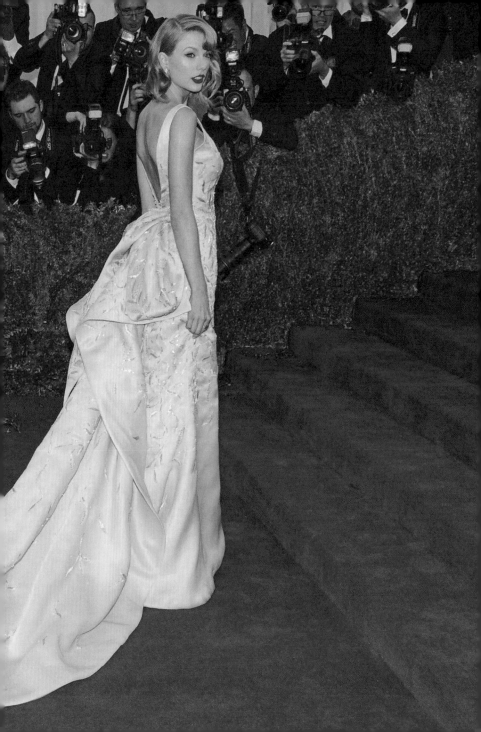

for your accomplishments and your fame." She finished the speech with "But if you just focus on the work, and you don't let those people sidetrack you, someday when you get where you are going, you will look around and you will know that it was you and the people who love you that put you there and that will be the greatest feeling in the world." The brains behind the ensemble, Donatella Versace, shared in an interview with *The Hollywood Reporter,* "She wanted a look that was young, sexy and fresh, as she is, totally reflecting her character. It was a pleasure to create this look for her. Taylor's gown is the perfect example of how bold color can create such an incredible effect." She went on to praise the singer, saying, "I'm very proud of this dress. Taylor is such an inspiration. She has become one of the biggest icons in the world in such a short time by being totally herself."

By 2016, Taylor's image had properly transformed from Country Girl-Next-Door to respected fashion icon. This shift was promptly acknowledged by some of the most influential names in fashion at the time, including *Vogue*'s Anna Wintour. Not only did Wintour insist on Swift attending the iconic Met Gala, but she also invited her to co-chair. The theme of the year was titled "Manus x Machina: Fashion in an Age of Technology", a theme that Wintour believed was perfectly fitting for Swift, likely due to her meteoric rise to fame being documented heavily on social media platforms such as MySpace and Instagram. "Obviously, her connection to technology was one of the reasons that we wanted to see if she would care to be involved," the celebrated editor mentioned in relation to the decision on the *Vogue* podcast.

For the 2016 Grammys Taylor's style was created by Atelier Versace and worn with sandals by Stuart Weitzman.

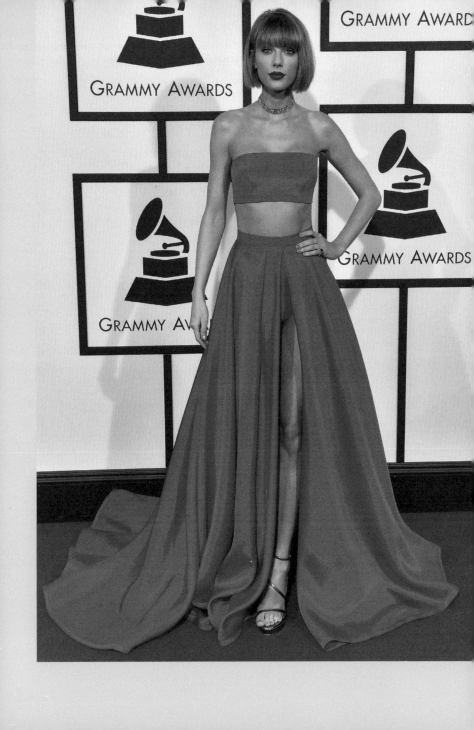

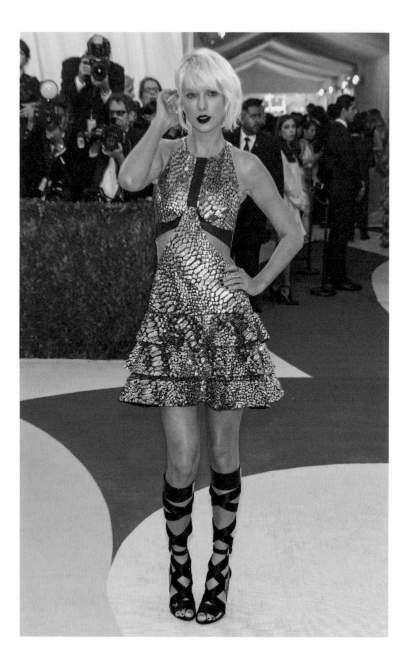

Taylor's red-carpet style proved to be one of her most memorable looks to date, with the focus being a custom Louis Vuitton minidress. In a quick chat with the legendary André Leon Talley, *Vogue*'s former editor-at-large, on the red carpet, Taylor dubbed her look as "futuristic gladiator", referencing the thigh-high strappy sandals that completed it. New York designer Eva Fehren provided most of the jewellery, including two rings, one notably featuring a wrap-around serpent style (a hint at Taylor's upcoming *reputation* album). Deep berry lipstick also played an important role in making an impression, later being identified by Swift's long-time make-up artist Lorrie Turk as Anastasia liquid lipstick ("Sad Girl" shade). Despite the name of the hue, Taylor would reportedly be anything but on the evening as she was spotted having a playful dance-off with future fling, actor Tom Hiddleston, at the afterparty. This would also be a key night in Taylor's story as she is rumoured to have met a later romance, Joe Alwyn, for the first time, with the singer referencing this in the 2017 track, "Dress", with lyrics about Alwyn's buzzcut and Swift's bleached hair.

Arguably one of Taylor's most memorable red-carpet looks, this metallic Louis Vuitton dress with side cut-out features was worn to the 2016 Met Gala alongside knee-high strappy sandals also from the French luxury fashion house.

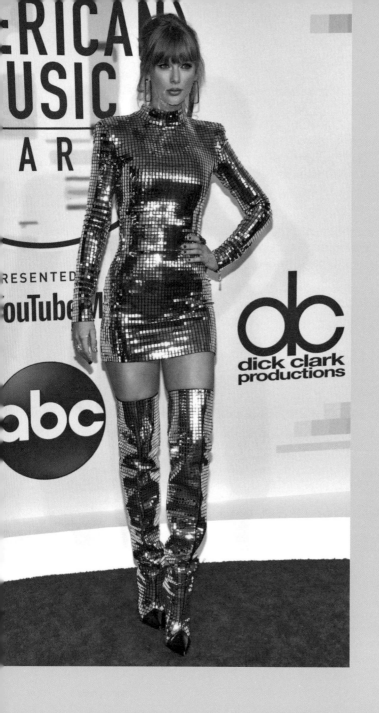

For the 2018 American Music Awards, Taylor looked to the unique talents of Balmain to create a style fit for the occasion. The result came in the form of a metallic minidress with long sleeves and a mock neck collar. It was covered in small mirrored squares and complemented by thigh-high stiletto boots complete with solid black toe caps. The singer finished the look with oversized rings and statement rectangular hoop earrings. Her make-up drew inspiration from the 1960s with a cat-eye liner style that complemented the modern beehive updo worn on the night.

The look surprised both fashion critics and fans alike (the latter referring to it colloquially as "the mirror-ball dress"), with the reigning Taylor Swift fashion blog, *Taylor Swift Style*, sharing, "Taylor very much took me by surprise with this look. Practically everything was quite unexpected on my part. The slight bouffant and 60s makeup, the allover disco look and of course going mini when I thought she would go long. I'm officially dubbing this look 'Retro Galactic Disco'." *Vogue* senior fashion editor, Janelle Okwodu, shared in a review, "If you'd gotten used to Taylor Swift's bohemian sundresses and kitten print sweaters, you may want to sit down. The pop star—who's been on a roll this week with surprises— stepped onto the red carpet at the American Music Awards sporting a bold look: a holographic silver Balmain minidress and matching thigh-high boots that transformed Swift into

OPPOSITE Taylor graces the red carpet of the 2018 American Music Awards in a light-catching Balmain minidress. "She's back to her sparkly ways," noted Andrea Park for *Teen Vogue*.

OVERLEAF On March 14, 2021, Taylor attended the Grammy Awards wearing a stunning Oscar de la Renta dress with Christian Louboutin sandals and Cathy Waterman jewellery.

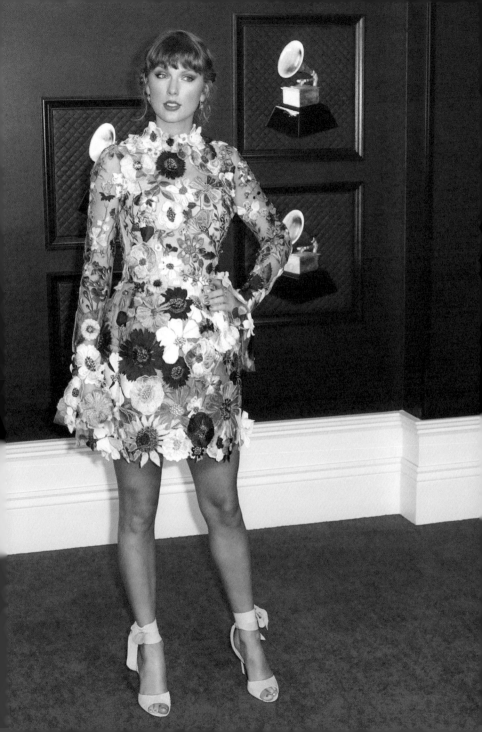

one of designer Olivier Rousteing's vixens." Rousteing is even reported to have taken inspiration from Taylor when designing pieces for the French luxury fashion house, telling *GQ* in 2015, "When I designed this collection I think it was a mix of so many different singers from Rihanna, to Kylie, to Taylor Swift, to Backstreet Boys, just everyone together." Taylor notably also wore Balmain designs in various looks from the *reputation* era, including a snake-print halter dress and a bright red wrap dress in the music video for "Look What You Made Me Do".

The 2021 Grammys marked another night of breaking records, with Swift winning the title of Album of the Year for the third time. This win was accredited to her surprise 2020 album, *folklore*. The unique affair came with a new set of rules, requiring attendees to wear masks for a portion of the event – a challenge that didn't stop Taylor from making a style statement that would find her topping Best-Dressed lists across the globe. The Oscar de la Renta dress was the brainchild of designers Laura Kim and Fernando Garcia and featured a whimsical floral design with a thigh-grazing hemline. The duo brought in the talents of floral artist Tricia Paoluccio to help create many of the season's botanical-inspired looks, including Taylor's minidress of the night.

On the day of the event, the Instagram account belonging to the Italian fashion house posted a video giving followers a closer look at the captivating design, quickly garnering a million views, with the caption, "Floral Folklore. A closer look at the making of @taylorswift's custom #grammys dress. In a bountiful display of late-summer's glory, botanical appliqués are tacked on individually to complete the look". And to the delight of fans, the style was a part of the label's Fall 2021 ready-to-wear line – so if you had a cool US $8,990 lying about, the look could be yours.

The iconic status of the dress wasn't lost on the team behind the awards show either. Soon afterwards the dress was displayed in the GRAMMY Museum for visitors to witness up close. Fashion consultant Cachita Hynes speculated on the deeper meaning behind it, sharing with The List, "If Taylor Swift was trying to make a statement with her gorgeous Oscar de la Renta floral dress on the carpet I would think it may be that she is now blossoming. It reminded me of a flowering tea ball, this beauty has been put into the boiling water, something [that] would burn or break most things." Yet instead, according to Hynes, Swift "has opened up and is born again and her drive, power and continued inspiration [are] as bold as her bloom."

Oscar de la Renta helped Taylor seize the spotlight once more at the 2022 MTV Video Music Awards, providing an undeniably glamorous look that, if Swifties are right, was far more than just a pretty dress for the occasion. Thirteen years earlier (the unlucky number being famous among the singer's fanbase for being the icon's favourite number and the date in December 1989 when she was born), a then 19-year-old Taylor wore a strikingly similar look to the very same awards show ("Kanyegate"). It's fair to say that a lot has happened in that 13-year period, notably the unstoppable rise of Taylor's significance in the pop culture world and the demise of Kanye's reputation. This had many referring to the diamond-clad minidress as Taylor's own version of a "Revenge" dress. Alongside the matching Christian Louboutin heels, the outfit signalled the star's talent for coming out on top. Her make-up for the evening included a cat-eye liner "sharp enough to kill a man" with bejewelled accents and maroon lipstick – ensuring that, despite the five award nominations for her "All Too Well" re-release video (from the *Red* album), some focus remained on her latest album, *Midnights*, too.

Taylor's dramatic 2022 VMA's Oscar de la Renta dress landed her on countless "Best Dressed" lists for the evening and from this snap of her ahead of the event, it's easy to see why.

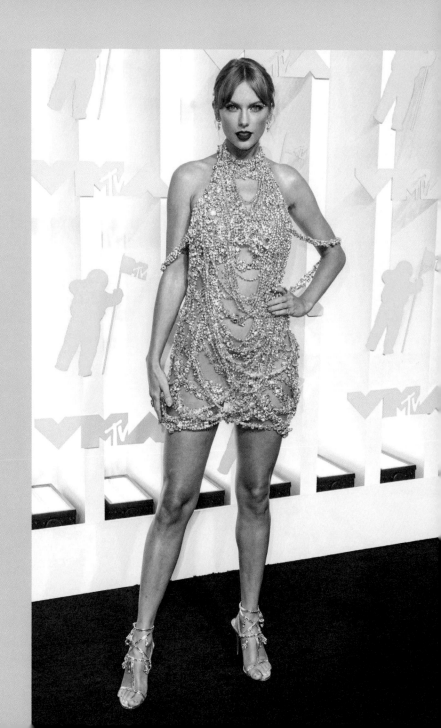

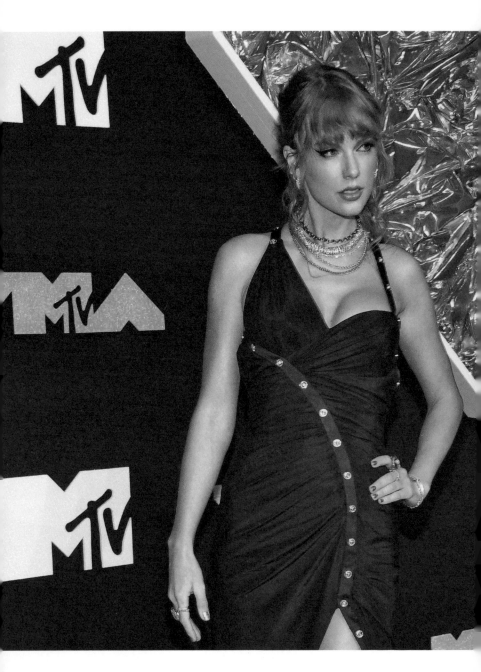

Taylor attends the MTV Video Music Awards on September 12, 2023 wearing a custom Versace dress.

Signature

CHAPTER 3

Pieces

As Taylor's style has evolved over her career, there are a few key pieces that manage to find their way into many of her looks or make a particular impact, becoming a fashion style that fans and onlookers easily associate with the star for years to come. Here, we'll explore some of those key pieces, from the playful miniskirt acting as an anchor in her outfits over the years to how knitwear styles have become a powerful metaphor in both her music and her aesthetic stories.

The miniskirt

Since first appearing in the public eye as a teen, Taylor has demonstrated her love for the miniskirt, seemingly at any chance possible. On the red carpet, on stage and on her days off, Ms Swift has looked to the style staple to demonstrate her evolving aesthetic, while making her legs a trademark (literally) in the process. By 2015, her dedication to the skater skirt style, in particular, had already made itself clear to fans and fashion critics the world over, including *Refinery29*'s Ana Colon, who referred to them as perhaps being, "Taylor's greatest hit. (Gasp! We kind of mean it.)" in an online piece titled "A Look Back At Taylor Swift's Love Affair With Skater Skirts" published on July 11, 2015. She goes on to highlight, "Whether it's the better half of one of her sets or the cheap thrill she can't get enough of (that's right—our girl frequents H&M and

A 19-year-old Taylor sports one of her trademark miniskirts with a Ralph Lauren shirt as she leaves her London hotel on August 21, 2009.

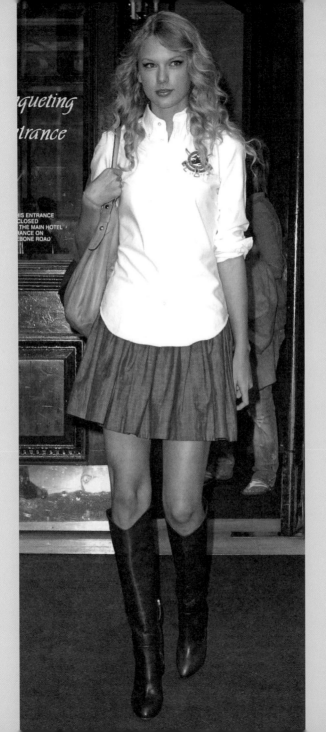

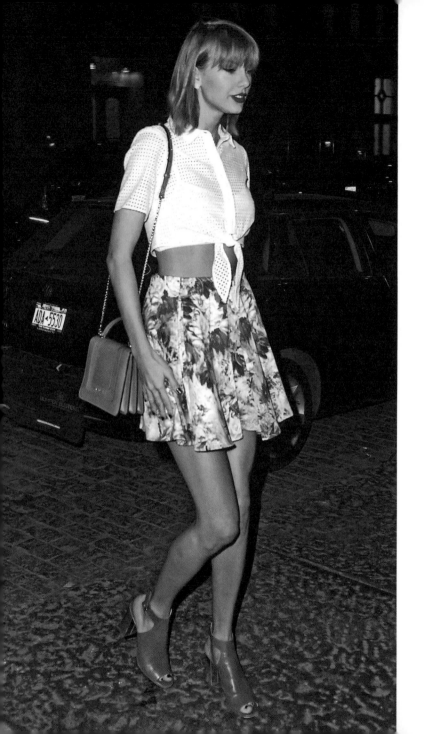

Urban Outfitters, just like the rest of us), Swift proves that a skater skirt may secretly be the most adaptable piece in your wardrobe."

In the first look, we see Taylor wearing a classic preppy style with a crisp white Ralph Lauren shirt, grey pleated miniskirt and knee-high leather boots during a trip to London between performing at V Festival in 2009. The outfit was very likely influenced by the teen drama series *Gossip Girl* style that had its grip firmly on much of the Western world at the time. Pretty cute to think that Swift and Blake Lively, star of the CW network hit show, would end up becoming long-time besties, six years later. The timeless short style would continue to make an appearance in the Swift wardrobe for many years to come.

In May 2015, Taylor was seen again in a short skirt style. This time it was when she headed out to dinner with supermodel pals Gigi Hadid and Martha Hunt, outfitted in a tie-front crop top by Michael Kors in a crisp white colourway and a high-waisted miniskirt by Haute Hippie, covered in a floral print that was perfectly suited for spring. The look was completed with Prada peep-toe heeled sandals and a Bulgari "Serpenti Forever Flap Bag" in emerald green (fun fact: Taylor wore the bag backwards, with the closure facing inwards so not on show. But Swifties noticed that it featured a snakehead closure – Easter egg?). The songstress loved this skirt so much, this would be the second sighting of the style, the first being at a fan meet-and-greet nine days earlier.

Taylor went for a floral Michael Kors style
for a girls' night out in May 2015.

The Brandy Melville Brya corduroy skirt was undoubtedly another one of Taylor's favourites, making plenty of appearances throughout 2015. From candid snaps featured on her Instagram account to grabbing dinner with actress and model friend Jaime King in LA, the Brya skirt is realized in black, burgundy and classic camel colourways, allowing it to seamlessly fit into many of Swift's off-duty looks. But the star's love for the American high-street label doesn't stop there: she's been known to sport countless looks over the years from the Brandy Melville racks, including wearing a knit top while posing for a selfie with a kangaroo on her Instagram in December 2015 and a floral tee for the 2020 release of the documentary concert film *folklore: The Long Pond Studio Sessions*.

In late June 2023, Taylor took a trip to Electric Lady Studios in New York, wearing the beloved miniskirt style – but this time with a very nineties twist. The Heartbreaker Skort from Free People is, well, not technically a skirt at all – but let's not get too hung up on the technicalities. The light-wash denim style is worn alongside an oversized shirt by The Row, a Le Petit Patou handbag, chunky lace-ups from Malone Souliers and a simple navy ballcap. "Skorts and mini skirts were not high on my list of nostalgic items to revisit in my summer wardrobe. Yet something about the way Swift first layered her initial Free People piece with a vintage NYU sweatshirt and sneakers from The Row compelled me to hit 'Order,'" *Harper's Bazaar* writer, Halie LeSavage, shared in a 2023 piece, appropriately titled "How Taylor Swift Swayed an Editor to Wear Skorts Again".

On March 2, 2015, Taylor was spotted in the black version of one of her favourite skirts, the Byra style from Brandy Melville.

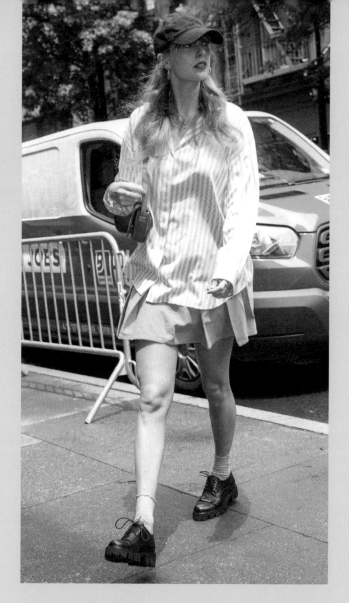

ABOVE "Taylor Swift Aces the Schoolgirl Look in a Baseball Cap, Button-Up Shirt, and Skort," reads an *Elle* headline on this June 2023 look.

OPPOSITE On November 2, 2023, Taylor headed out in New York City wearing a Miu Miu pleated skirt alongside above-the-knee boots and bucket bag from Stella McCartney.

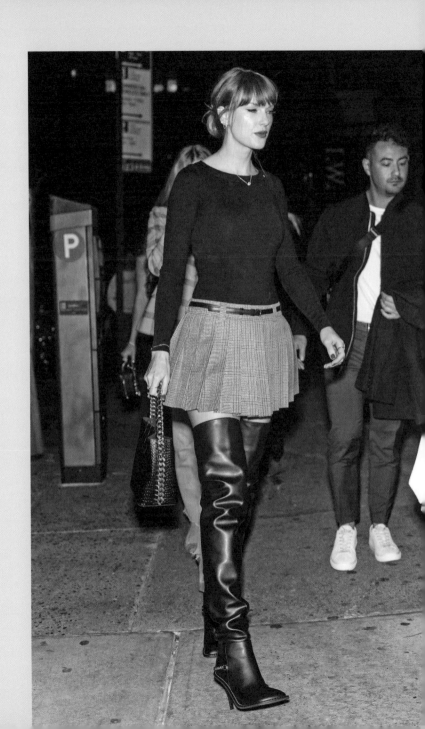

Nice knitwear

Yes, Taylor has occasionally been spotted out and about wearing knit scarves or oversized cardigans, but as any fan of the star will know, it's more about the significance of knitwear in her songs than the frequency of these cosy styles in her public outfits. Exhibit A: The scarf. A simple winter accessory to many, but *far* more than that for any true Swiftie. Referenced in one of the singer's most noteworthy and emotional tracks, "All Too Well", the illusive scarf has become a garment rich in symbolism and association with heartbreak in the world of TS. The song, originally released in 2012 on the album *Red*, includes lines that express the young songwriter leaving a scarf at the home of the subject's sister and how they still have it in a drawer "even now". The general consensus is that this is in reference to Taylor's relationship with actor Jake Gyllenhaal, which took place over a three-month period in late 2010. Though the original release didn't come with an accompanying music video, the extended re-released version in 2021 was quickly followed in the same year by *All Too Well: The Short Film*, starring Sadie Sink and Dylan O'Brien. This would be where the famous red scarf would make its first appearance.

Taylor takes a Thanksgiving stroll with actress Maggie Gyllenhaal and Maggie's daughter Ramona in Brooklyn, November 2010.

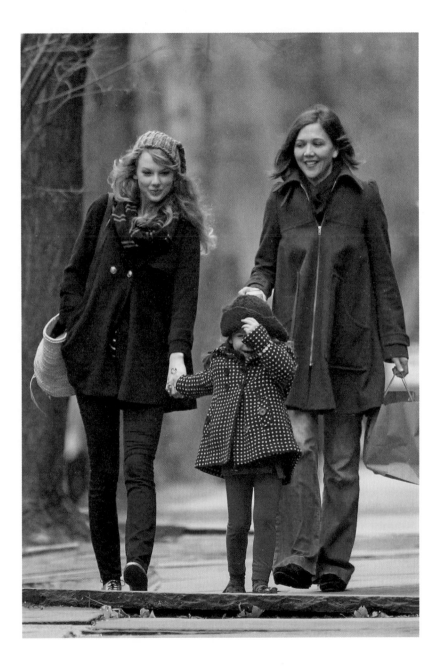

In a talk to promote the film at the 2022 Toronto International Film Festival, Taylor addressed the symbolic role of the red scarf directly, saying, "The scarf is a metaphor [...] and we turned it red because red is a very important color in this album, which is called *Red*." So there never really was a red scarf, *per se*. But there was definitely *a* scarf. The reigning theory is that the scarf referenced was actually a navy style with grey stripes from Burberry that was spotted on Taylor during a romantic stroll with Gyllenhaal in November 2010, and then worn by the actor himself to the *Harry Potter and the Deathly Hallows: Part 1* premiere in London. The red knit style featured in the 2021 short film was replicated as a piece of merchandise available for fans to purchase and featured a tab on the hem that read "All Too Well" on one side and "Taylor Swift" on the other.

In December 2021, *Pulp* editor Jordyn Buhagier wrote about the symbolism of the scarf in a piece titled, simply "The legacy of the red scarf". Buhagier shared her interpretation of the scarf being a symbol of innocence and a metaphor for the transformative nature of heartbreak. She goes on to talk about how, like the "All Too Well" scarf, youthful passion and vulnerability can be worn without fear, "only to be taken away and kept in someone's bedside drawer".

A grey knit scarf from Nordstrom completes Taylor's look as she spends a day out in London, January 2012.

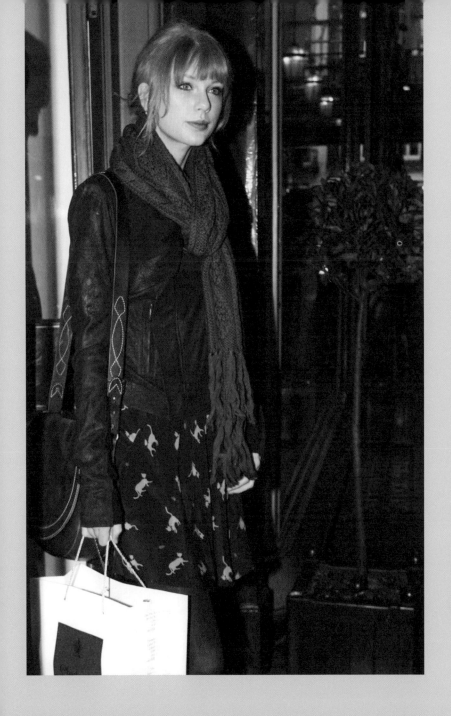

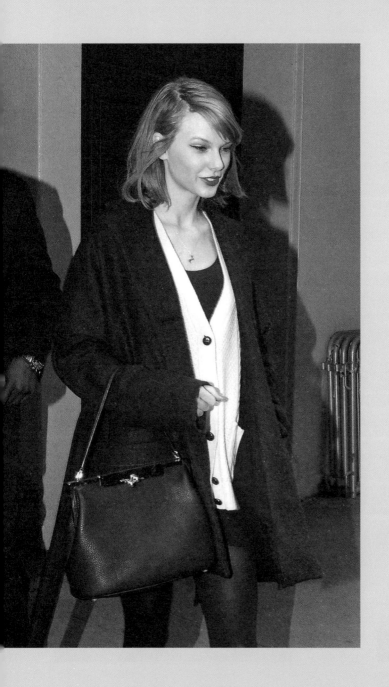

Though Ms Swift flirted with knitwear themes and references, and of course, was spotted in the very of-the-time slouchy knit beanie and humble knits during the earlier portion of her career, many can agree that the *real* knitwear era was set around the *folklore/evermore* releases of 2020. First, there was the track aptly labelled "cardigan", which prompted a surge of interest in the unassuming garment from Swifties across the globe. So much so that Taylor and her team knew they had to release the style as one of their pieces of official merchandise. Then there was the Aran sweater. Perhaps simply chosen for its vintage feel and cosy practicalities, the Aran also packs a rich history in folklore (yes, *folklore*) that can't be ignored. A 2020 *Vogue* piece titled "Taylor Swift is bringing centuries-old knitting traditions back into demand—here's how" discusses how the history of the knit has been long disputed after a wool shop owner named Heinz Edgar Kiewe tried to promote fabricated stories about the knit style dating back a thousand years. The truth of its origins is still a bit grey but we do know that the first time the Aran jumpers appeared for sale in shops was around 1900. The knit features a few patterns which *Vogue* writer, Rosalind Jana reports are said to "be imbued with different symbolic meanings ranging from luck with fishing to hopes for future wealth."

Taylor sports a cardigan look during a trip to New York's Lord & Taylor department store in March 2014.

By the time the *Midnights* era rolled around, Taylor's affinity with knitwear had only grown stronger. *Stylist*'s Naomi May highlights this in a 2022 article titled "Taylor Swift has a new favourite earth-friendly cashmere brand", stating, "Many things have changed since Swift's rapid ascent, but some things stay the same – and that is certainly true of the musician's love of a good knit." The songstress reached for cosy styles from LA label Reformation for her TikTok series, "Midnights Mayhem With Me", sporting the Leone minidress and a classic polo jumper, both crafted from recycled cashmere. It seems Taylor's wardrobe was full of knitted looks around this period: she was seen wearing a chevron crochet top from Mother in a video discussing the track, "Anti-Hero", this, in turn, prompting plenty of crafty fans to share their own versions of the top online (the original was an instant sell-out, of course). In fact, the singer's obvious and increasing affinity for knitwear throughout her career might be one of the causes behind an influx in fans knitting and crocheting their own versions not only of sell-out styles seen on the star, but also her merch (hello, *the* cardigan) – and even extremely intricate tour posters and other imagery. But more on this phenomenon in the next chapter ...

Taylor looks to the Americana preppy style masters that are GANT for this collared knit style, worn here in November 2023 alongside trousers from The Row and heeled loafers from Parisian label, Sézane.

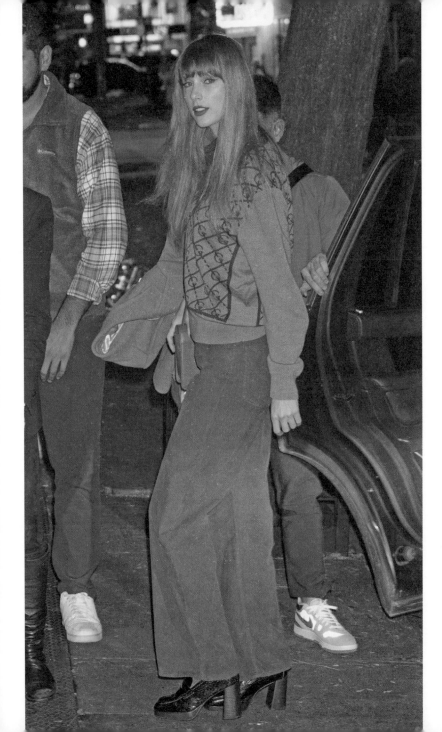

"The singer has anthropomorphised the much-worn but hardly glamorous clothing item and also made it a *sartorial* mascot."

LAUREN COCHRANE, FASHION WRITER

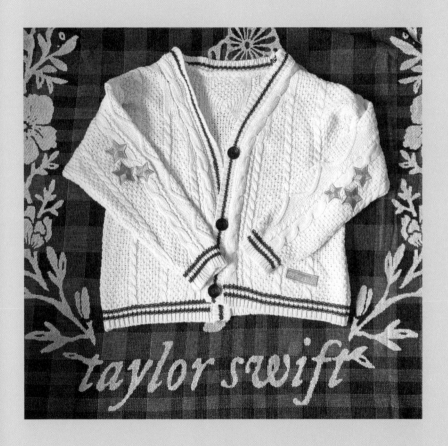

To coincide with the release of her album, *folklore*, in July 2020, Taylor offered
fans the opportunity to get a cardigan of their own. The cardigans came
complete with a branded badge and embroidered stars near the elbows.

Taylor shows off her love for cats with this Anya Hindmarch bag
for Gigi Hadid's birthday on April 22, 2019 in New York.

Handbags

The power of the trusted leather handbag has never been lost on Ms Swift, who has sported a strong rotation of them across her career. While some would make appearances long after they were first spotted on Taylor's arm (hello, Easter eggs?), many would act as something of a time capsule for particular eras. Taylor herself is open about using her fashion to send messages to fans, telling *Entertainment Weekly* in 2019, "Easter eggs can be left on clothing or jewelry [...] This is one of my favorite ways to do this because you wear something that foreshadows something else and people don't usually really find out this one immediately but they know you're probably sending a message. They'll figure it out in time."

But beyond the world of TS Easter eggs, we can speculate on how she uses accessories as a communication tool by looking at a 2017 piece titled "The Psychology of Designer Handbags" by Alexandra Shulman in Business of Fashion, who shares, "For most women, their handbag is a multi-tasking device that combines the virtues of practicality and utility: along with showing off personal taste, it suggests a certain economic prosperity and acts as a soupçon of the childhood security blanket. While women may often play it safe, either due to workplace convention or simply their lack of interest in clothes and so choose to dress unremarkably in their daily life, these same women will frequently have a standout handbag."

Though Taylor had dabbled with handbags during her earliest eras, they were often the slouchy "hobo" style that were popular with many young women of the time. It wasn't until around 2012 that she started moving into more elevated styles and designer names. One of the first of her favourites appears to be the classic Coach "Court" bag, which she sported on a number of notable occasions including outings with then-boyfriend, British singer-actor Harry Styles, and while grabbing an iced coffee with a friend in Santa Monica. The handmade leather bag was a part of the American label's collection, comprised of reissued styles that helped cement the brand's spot as a favourite among fashion editors and celebrities alike throughout the nineties. Vintage versions continue to be a much-coveted accessory on preloved shopping sites today. Taylor is also known to have carried other Coach bags, including the Coach "Legacy Leather Amanda Flap Bag" and "Legacy Leather Mini Saddle Bag" – both reissues of nineties originals.

As the singer moved into her 1989 era, we witnessed another shift into higher-end staples worn alongside more casual and accessible styles. The Dolce & Gabbana "Agata" bag featured heavily among many of Taylor's key looks throughout 2014, including a simple ensemble featuring a navy double-breasted pea coat, maroon slim-fit trousers and green ankle boots from & Other Stories and a striped infinity scarf. The D&G design also featured in a particularly striking all-black look sported

Showing her love for the Coach Court Classic Bag, Taylor wears the style as she leaves her hotel in New York on December 6, 2012.

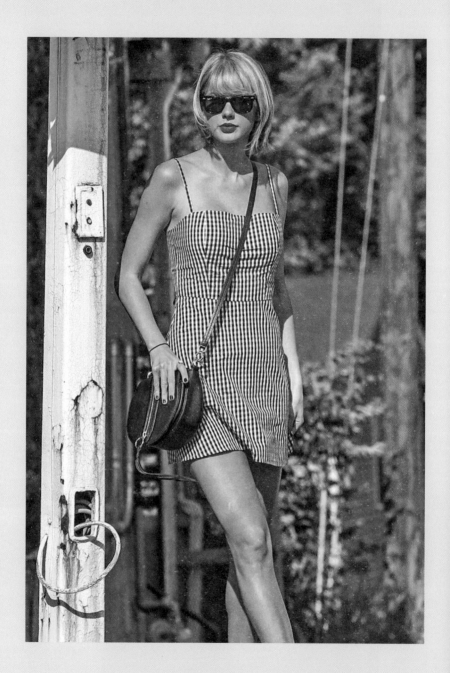

by Taylor during another NYC outing in July of that year. This time she wore it alongside a strapless jumpsuit from Reformation, Christian Louboutin "Karina" Ankle Booties and, of course, Ray-Ban sunglasses.

And then we have the Rebecca Minkoff "Mara Saddle Bag". A firm favourite among Swifties, the cowhide cross-body bag made its debut on the shoulder of Ms Swift in 2016, notably during what some refer to as Taylor's "Hiddleswift" period (one of her most-photographed eras). The bag was seen worn on outings from a visit to the Country Music Hall of Fame in Nashville to Suffolk countryside jaunts with then-boyfriend, British actor Tom Hiddleston, and his family. But though fans might have thought they'd seen the last of the leather number, the Minkoff design made another appearance during a dinner outing in April 2023 in New York. Taylor styled the bag with a pair of faded black jeans over a black bodysuit and platform boots from The Row. The unexpected revival had fans speculating online if this resurgence might be another clue from Taylor or just a mere coincidence. Something tells me that by the time this book goes to print, they'll have figured it out.

On June 23, 2016, Taylor wore the Rebecca Minkoff "Mara Saddle Bag" atop a gingham dress from Reformation for an outing in Nashville.

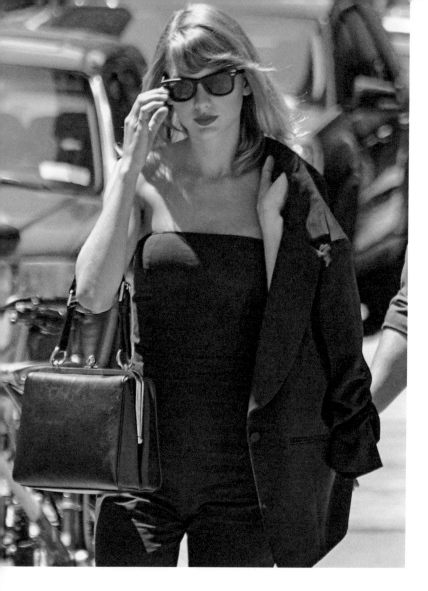

ABOVE Taylor's love for D&G handbags prompted plenty of articles dedicated to the affinity, including a 2014 piece titled "Taylor Swift and her Dolce & Gabbana bag: A love story" by the *New York Post*.

OPPOSITE A testament to its versatility, here Taylor sports the D&G bag on a crisp December day in 2014.

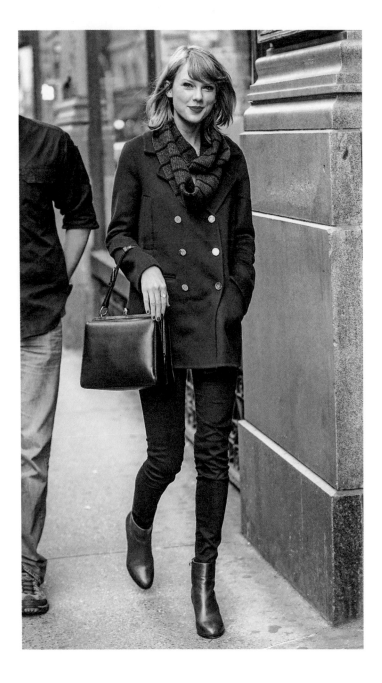

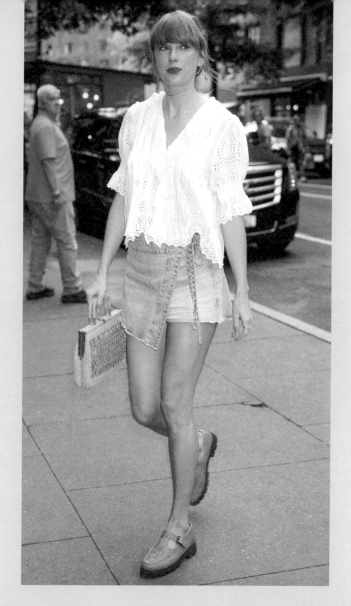

ABOVE Rumoured to be a vintage piece, this handbag was styled with a Dôen top, Free People skort and GH Bass loafers for a visit to her New York studio on June 27, 2023.

OPPOSITE The Louis Vuitton "Camera Box Bag" made a handful of appearances through the summer and autumn months in 2023, including this one in New York in October.

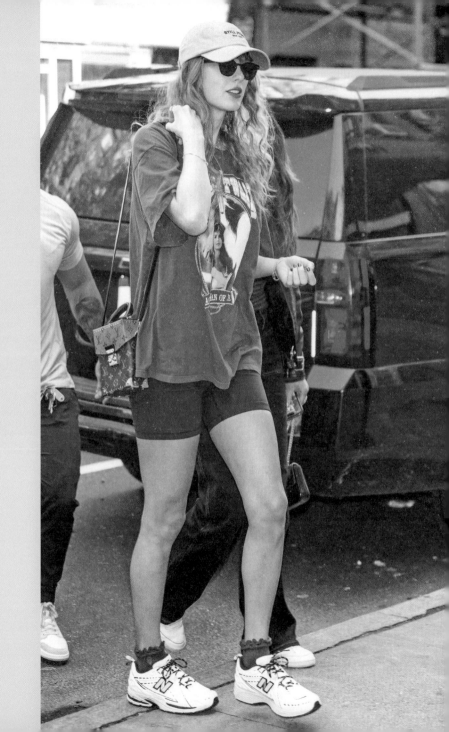

Sequins

Taylor's love of shiny sequins started pretty early on in her career, reaching for the glistening styles in a number of her earliest on-screen performances, including a set on NBC's *Today Show* in May 2009. The teal minidress came to life as the 19-year-old Swift sang early hits such as "Love Story" and "Teardrops on My Guitar". Knee-high leather boots from the label EVERYBODY fill in for the playful cowboy-boot style that was a staple for the singer at the time, allowing her to lean away from the Western looks and explore the broader world of fashion.

"For some, wearing sequins offers a celebratory moment; a sense of finding the silver lining. In that sense, sparkle evolves some sense of optimism and hope that good things are about to come" – Dawnn Karen, fashion psychologist, shared with Fashionista.com, 2018.

Taylor performs in one of her earlier sequined looks on the NBC *Today* show on May 29, 2009.

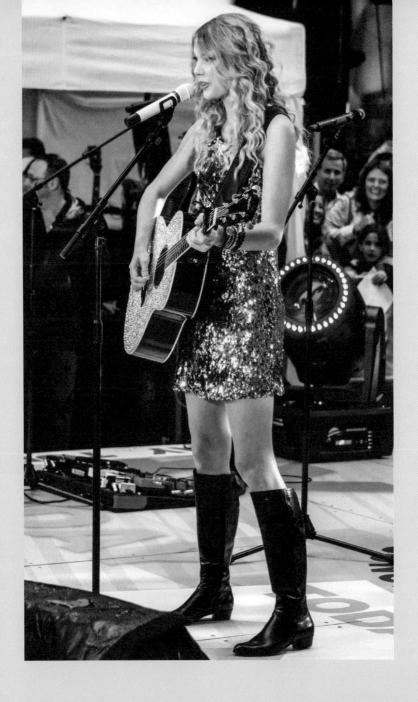

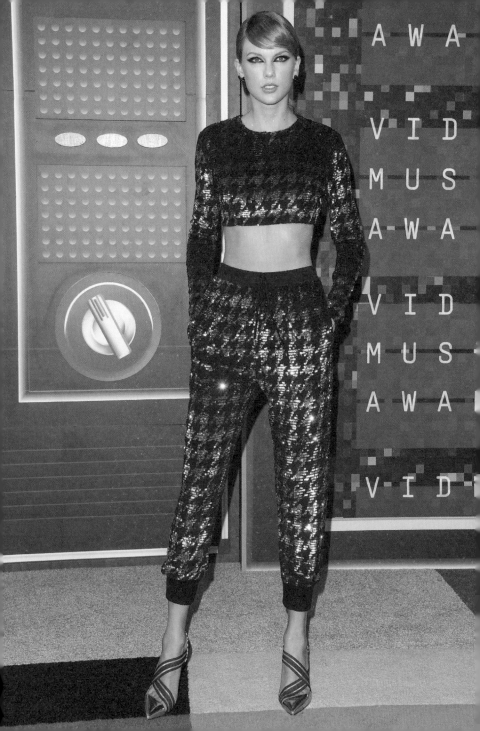

"*There are a few givens we all share in life: We are all born, we all die and we all know that when Taylor Swift changes up her style, a new album is imminent.*"

KATE EDWINA, FASHION WRITER

For the 2015 MTV Video Music Awards (VMAs), Taylor sported a sequin houndstooth Ashish top and trousers set with shoes by Christian Louboutin.

"I wanna love glitter and also stand up for the double standards that exist in our society.

I wanna wear pink, and tell you how I feel about politics. I don't think those things have to cancel each other out"

TAYLOR SWIFT
MISS AMERICANA
(NETFLIX, 2020)

Ahead of her 2017 *reputation* release, Taylor once again looked to sequin styles to capture the gaze of onlookers with the help of the iconic fashion house, Saint Laurent. Featured on the cover of the May 2016 issue of *Vogue*, Ms Swift wore a slinky minidress from the label's Spring/Summer 2016 line. The shimmering slip design was complemented by a platinum blonde Taylor that got fans talking and ultimately dubbing the subsequent era as "Bleachella" (it was initially spotted at the Coachella music festival, you see). "We actually did a double take when we first spotted the cover. Her short crop (which she snipped back in February) has been bleached a badass shade of blond, complete with '90s-style dark roots. Even with her signature cherry-red lips, Tay still looks like a whole new woman," wrote *Refinery29* writer Maria Del Russo. But this wasn't to be the first time Taylor would sport a Saint Laurent look that would make headlines. A few weeks earlier, the singer appeared at the iHeartRadio Music Awards in Los Angeles wearing a sequin-covered catsuit that also hailed from the Paris label's Spring/Summer 2016 collection, the final collection of Hedi Slimane before he stepped down from the role of Saint Laurent's creative director. These looks proved that, despite Taylor's shift into, as *Vogue*'s Anna Wintour called it, "a sort of a rock 'n' roll chick" look, sparkles and sequins would never be too far from reach.

On April 3, 2016, Taylor graced the iHeartRadio Music Awards red carpet wearing a Saint Laurent catsuit covered in sequins.

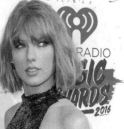

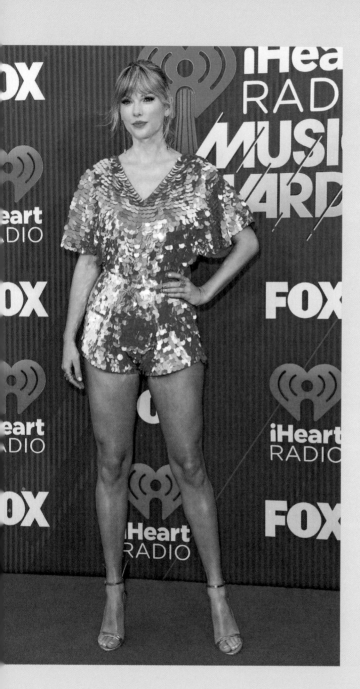

The *Lover* era was full of playful looks, heaps of colour and, you guessed it, sequins galore. One of the most notable styles was displayed on the red carpet of the 2019 iHeartRadio Music Awards, where Taylor donned a shimmering lilac romper from London label Rosa Bloom and shoes with butterfly-clad heels from Sophia Webster. Her blonde locks also got a dose of colour with a pink streak displayed as she accepted the award for Tour of the Year for her record-breaking 2018 *reputation* tour. The impact of the look on the public was highlighted with top London attraction Madame Tussauds opting for their waxwork of Ms Swift to be wearing the playsuit in their 2019 update.

"Taylor Swift was the best-dressed in an eye-catching £185 purple sequin ensemble by Rosa Bloom," shared Charlie Teather of British *Glamour* on this March 2019 look.

The Eras tour was another testament to TS's love of all things shiny, with the icon incorporating sequins or shimmering gemstones of some kind into virtually every look. One of the most impactful was a Nicole + Felicia design worn for the *Speak Now* section of the show on many of the tour's American dates. If the gown looks familiar, it could be because it's speculated to have been inspired by the Valentino design that Taylor wore on her original *Speak Now* tour, a look that has landed itself as a favourite of many Swifties. The sister-run label behind the Eras look is also responsible for more of Taylor's show-stopping outfits, including the red and white gowns featured in the "I Bet You Think About Me" (Taylor's Version) video (yep, the ones that took a whopping 1,200 hours to make!). But the glistening gown in question will undoubtedly go down in history as one of the top sequinned styles worn by the singer, with an impressive 200,000 hand-sewn sequins and crystals covering both the bodice and the skirt section. The impact wasn't lost on fashion critics either, with British *Vogue* commenting in March 2023, "The most dramatic, of course, was the full-on princess gowns by Nicole + Felicia that Swift wore to perform 'Enchanted' in – an enchanted design indeed."

OPPOSITE Taylor wears a shimmering Louis Vuitton dress to the Toronto Film Festival on September 9, 2022.

OVERLEAF Houston, Texas shimmered on April 21, 2023, as Taylor wore this Nicole + Felicia Couture gown on-stage for the *Speak Now* section of the show.

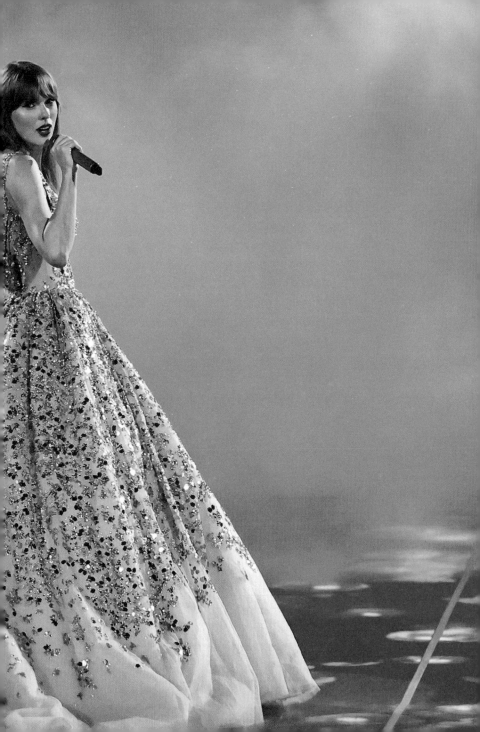

"Wayfarers"

The Ray-Ban "Wayfarer" style dates back to the early fifties with the brand fast becoming a hit for its versatility and cool factor. In a May 2023 piece in *GQ* titled "The best Wayfarers for an A-list-approved pair of shades", the impact of the sunglasses was summed up: "Prior to Ray-Ban launching its Original Wayfarer in the mid-1950s, men's sunglasses were purely functional. They were tools for a job. Nothing more, nothing less. But this chunky, square-framed style turned them into a must-have fashion item for the first time." It wasn't too long before the trapezoidal design went beyond the Ray-Ban brand and would become – as many would agree – the default shape of sunglasses around the world. The magic wouldn't be lost on Ms Swift, with the songstress spotted wearing these shades as early as 2010 with her off-duty styles.

A 20-year-old Taylor was spotted out shopping in Beverly Hills, wearing red-frame Ray-Bans on September 11, 2009.

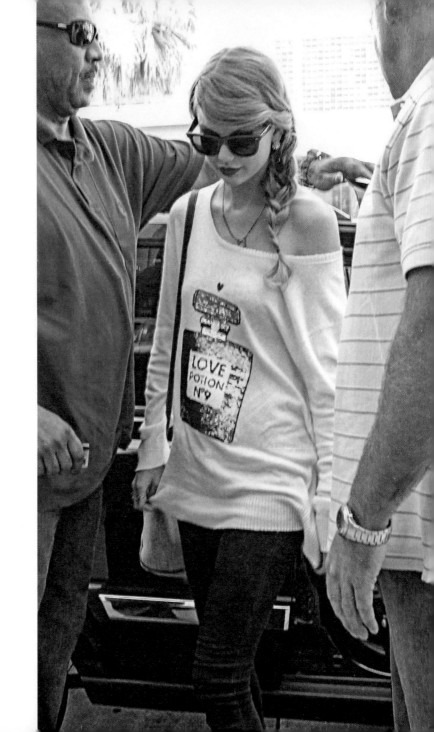

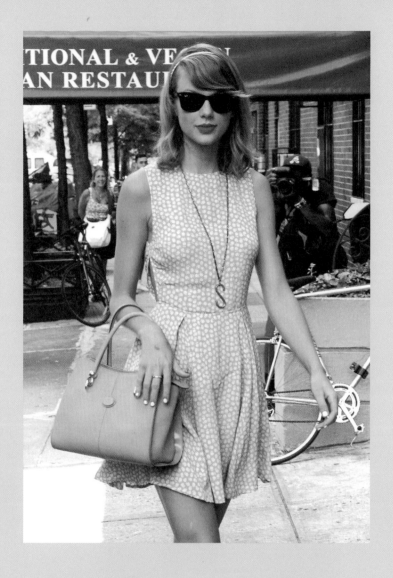

ABOVE Taylor sports Ray-Bans as she heads to Angelica
Kitchen in New York on July 22, 2014.

OPPOSITE Wayfarers would also be a key piece of Taylor's post-gym
looks in the *1989* era, like this pair spotted on June 30, 2014.

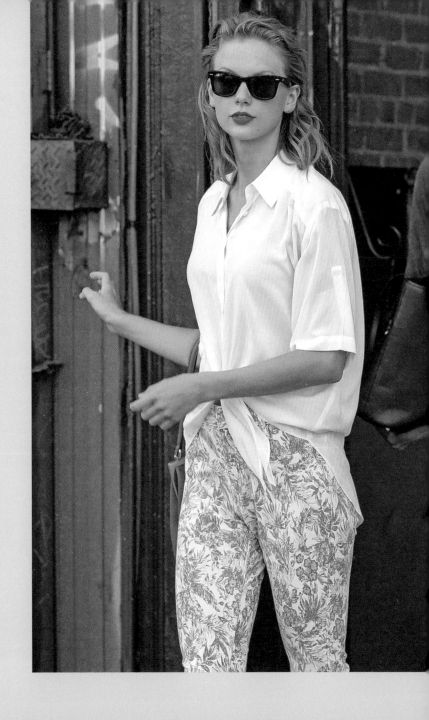

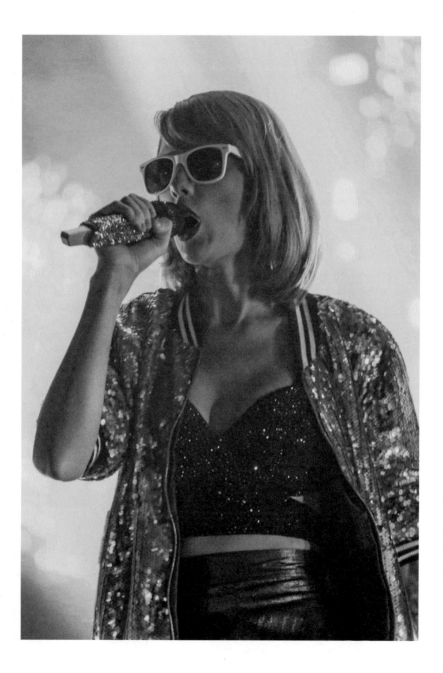

By 2012, Taylor was wearing the style a lot more, both on and off the clock, including in the "22" music video (alongside her favourite heart-shaped style, of course) and for the *Red* album photo shoot. But it would be 2014 before she really cemented her relationship with the "Wayfarer" look. The singer would be frequently spotted in the design, including various summertime outings in New York, worn with a mint green Reformation dress, Tod's leather handbag and fuchsia Christian Louboutin heels. These sightings would lay the foundation for her to demonstrate her true enthusiasm for the "Wayfarer" with the release of the 1989 album and the subsequent tour of 2015. The official Taylor Swift merch reflected this by presenting a blue-rim style with "T.S." and "1989" featured on the temples.

Fast forward to 2023 and Taylor was still showing her love for the timeless style, but by now straying on occasion from the original Ray-Ban version and infusing various reinterpretations of the shape like the style pictured overleaf from Anine Bing, paired here with a black maxi dress and Mansur Gavriel bag during a quick outing in New York between her Eras tour dates.

Taylor wears Wayfarers during a performance in Shanghai, China, on November 10, 2015.

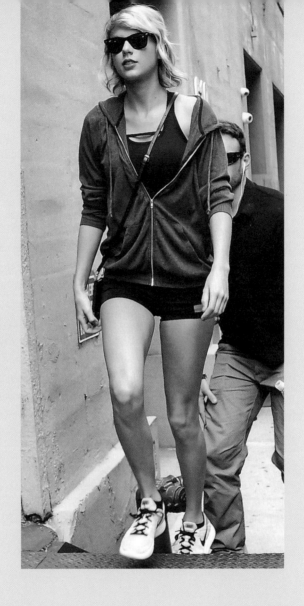

ABOVE The "Bleachella" era wasn't immune to Taylor's love for Wayfarers either, as demonstrated in this gym look from August 10, 2016.

OPPOSITE For a May 2023 outing in New York, Taylor brought in the talents of Scandi/Cali fusion label, Anine Bing, with these Wayfarer-inspired shades.

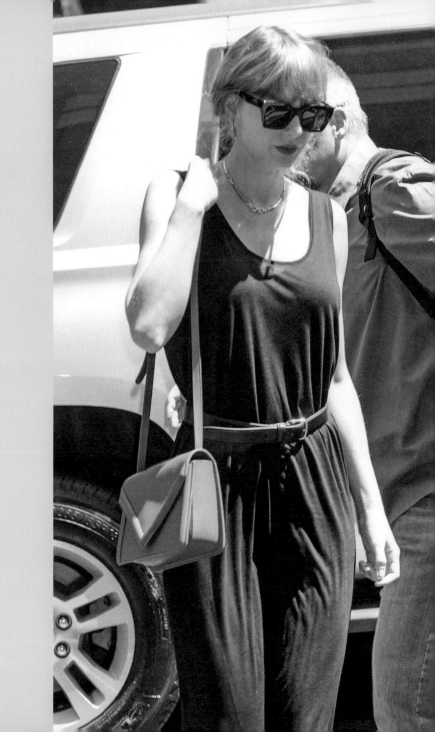

Swift

CHAPTER 4

Impact

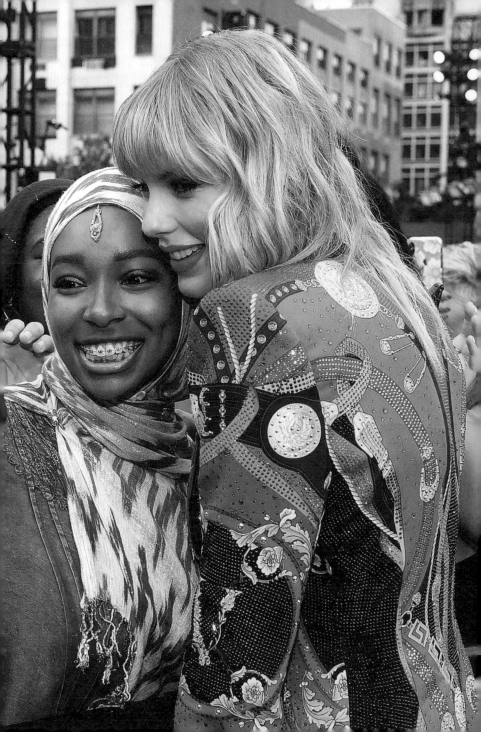

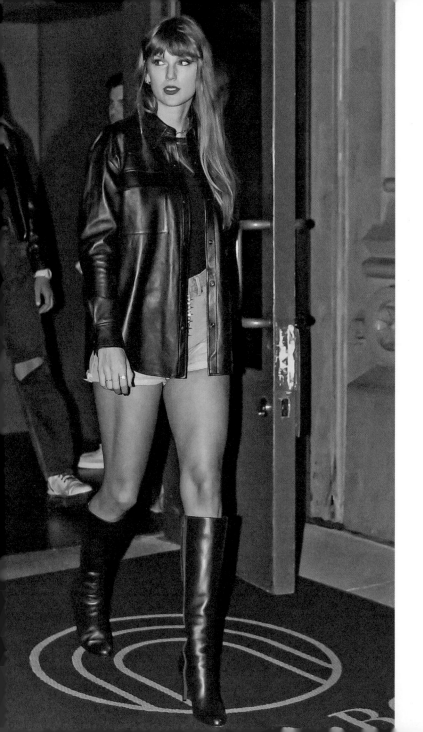

Though a pop star's work may *feel* like the most important thing in the world to their fans, it's rare that the actual impact is truly as unprecedented as Taylor Swift's career has had on not just pop culture, but the world economy. Countless academic papers have been written on how her mere presence in a city can have serious impacts on the businesses and transport systems of that city during her stay. In August 2023, *Harvard Gazette* shared, "Swift's 131-date 'Eras' world tour, currently packing stadiums across the U.S., is on track to be the highest-grossing concert tour of all time, at $1.4 billion, when it ends next year. Analysts estimate the tour will also have a total economic impact from tour-related spending of $5 billion on host cities. Even the Federal Reserve noted the effect her tour is having on regional economies."

In July 2023, her Eras tour dates in Seattle, Washington, famously generated seismic activity equivalent to a 2.3 magnitude earthquake. Proving the power of Swifties, in case anyone wasn't convinced.

PREVIOUS Wearing a Versace blazer, Taylor takes a photo with fans outside the 2019 MTV Video Music Awards on August 26, 2019.

OPPOSITE Taylor is spotted wearing a GANT shirt, denim shorts from AREA and Christian Louboutin boots during an outing in New York on October 1, 2023.

"If there is anything that Taylor Swift has taught me through her music and career, it is this:

Storytelling is one of the most powerful acts in the universe. Never underestimate it, even when it comes to your clothes"

SAMANTHA HARAN, JOURNALIST

In the world of style, Taylor's impact runs deep. Following the release of *Red (Taylor's Version)* in 2021, it's reported that Google searches for "what red lipstick does Taylor Swift wear?" increased by 800 per cent. Saskia Van De Ven of commerce company Productsup shared with *Vogue Business*, "A simple change from 'sparkly dress' to 'Swiftie sparkly dress' can make your products more visible to shoppers searching for Taylor Swift outfits. Then by directing those ads to the right demographic and in the right locations, you're much more likely to see a higher ROI [return on investment] on ad spend." Wherever you look, Taylor's impact on the world of style is clear.

All Too Well: The Short Film won the award of Favourite Music Video at the 2022 American Music Awards, where Taylor appeared in gold jumpsuit from New York label, The Blonds.

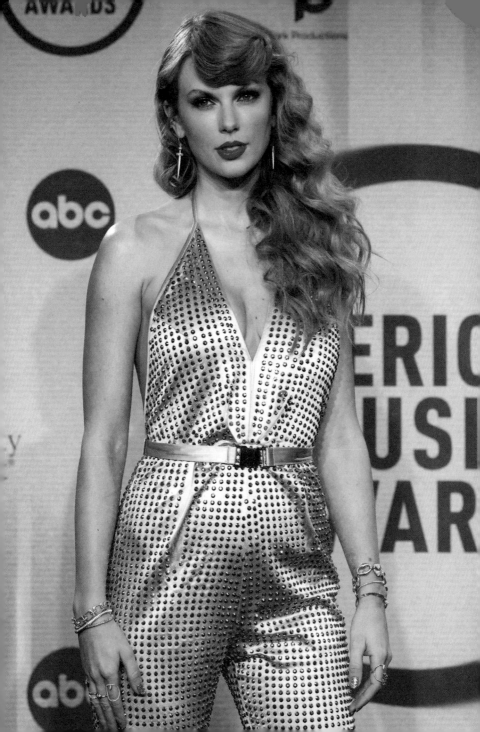

"*I love to* **communicate** *through* **Easter eggs** *[...]* *I think the best messages are* *cryptic* ones"

Sartorial storytelling

One of the key themes that sets Taylor apart from other musicians of her status is her unique ability to communicate with fans without saying a word. From the early days of her career, Ms Swift has shown a keen interest in sending hints to fans through not only social media posts and design choices on tour posters or album art but more importantly (for this book, anyway!), her outfits. Both on- and off-stage, the multihyphenate icon is known to sprinkle symbols that send Swifties into a tailspin as they attempt to decipher their meanings. This unique kind of engagement with fans is arguably one of the reasons behind her long-term success – it ensures there's always a puzzle to be solved and often has Swifties racing to be the first to crack the code.

The looks with hidden messages range in transparency, from wearing a starkly similar design to the same awards show years later to particular shades of nail polish featured in an Instagram photo. And though it might be easy to assume that Taylor's fans may be a bit overzealous with their speculations, it does seem that they're often not far off. To the average civilian, it may seem that perhaps the singer was just having fun with some old bottles of nail polish, but the Swifties knew better – and they were right.

OVERLEAF A San Diego Swiftie wears nail polish colours representing Taylor's albums during her show at the Citadel Outlets on August 1, 2023.

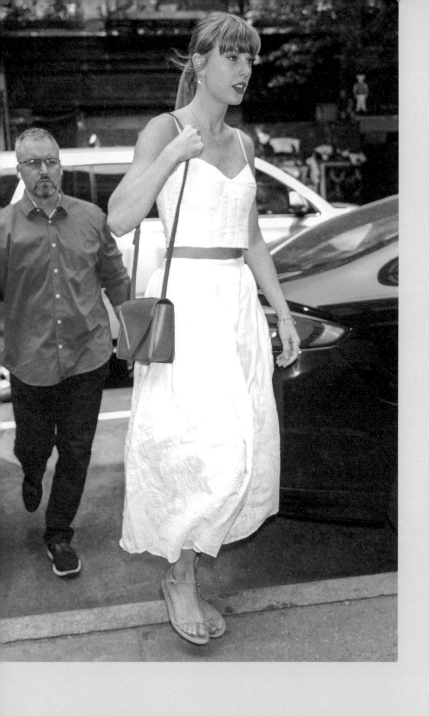

"There's also a badge with a lilac, baby blue and pink colour scheme which is very much the colours used in the 'Me!' video." Taylor confirmed to *Entertainment Weekly* that a Spotify video she did for "Delicate" in 2018 – where her nails were painted in pastel shades – was a direct Easter egg "to give fans an idea about what the colour scheme would be for the video".

On March 16, 2023, just one day before the Eras tour kicked off in Glendale, Arizona, she shared some candid shots of rehearsals for the tour's opening night. Among them was a shot of some colourful nails that instantly sent Swifties into a frenzy to decode the unique colours. The colour pattern can now be seen on the nails of some of the most dedicated Swifties at the star's shows across the globe.

This dynamic is something Taylor has discussed in interviews before. When talking about her "Look What You Made Me Do" video, she told *Entertainment Weekly*, "Literally the whole video is just an Easter egg [...] There are thousands of Easter eggs. There are some that people still haven't found. It will be decades before people find them all." The video showed Taylor in an array of looks, including many from her previous music videos like the tee covered in friends' signatures from "You Belong With Me" and the blue gown worn in the "Out of the Woods" video. In 2023, Taylor used the stage of her Eras tour shows to signal to fans that the launch of *1989*

As Taylor stepped out in this breezy Ralph Lauren set in May 2023, fans speculated that the similarities to many of her 2016 two-piece looks was the star's way of hinting toward an upcoming release of *1989 (Taylor's Version)*.

(*Taylor's Version*) was imminent by sending clues through her wardrobe choice. On August 8, 2023, Taylor took the stage in a never-before-seen bodysuit by Zuhair Murad. But though fans may not have seen this exact style, some were keen to point out how it resembled a look that Taylor wore on her *1989* tour in 2015. The next night (a date that read 8/9 in the American format, you see), a total of five different styles shifted to blue colourways, leading up to Taylor making the official announcement that *1989* (*Taylor's Version*) would be launching in a few months' time.

Street-style looks are also often under the ever-powerful microscope of the Swifties, demonstrated in a seemingly simple springtime look sported by Taylor in 2023. "The Hidden Message Behind Taylor Swift's Cutoff Denim Shorts, According to Fans" read one article by senior fashion editor at POPSUGAR, Sarah Wasilak. The piece outlines the similarity between the 2023 outfit and a look sported in 2018. The latter was featured in a key scene where Taylor opens up about her struggles with body image and disordered eating. It showed the world a new side to the star and prompted an influx of support from fans with Lady Gaga notably commenting on a TikTok post of the film scene in which she praised Taylor for being brave.

A cryptic message or simply a nice top and shorts pairing? Taylor wears R13 as she steps out in Greenwich Village on May 22, 2023.

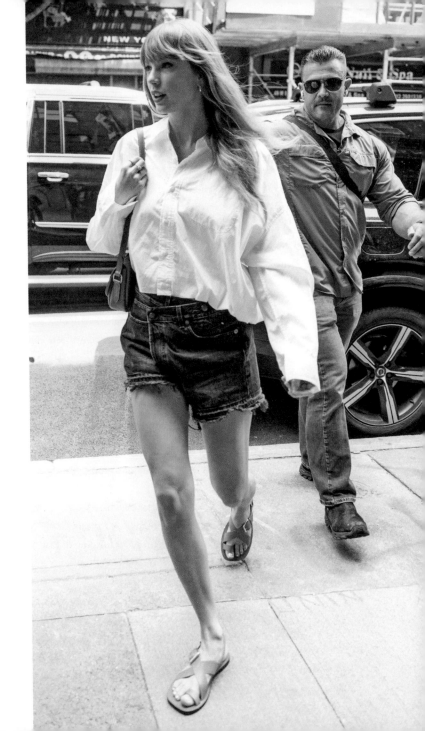

The Swifties' wardrobe

Most people will know that the act of fans dressing up as their favourite performers is nothing new. Any performer or band with more than a handful of superfans understands that the outfits of those in the audience can be a telling marker of the strength of the community around them. In an article for *NPR*, Carrie Brownstein, guitarist of iconic riot grrrl group Sleater-Kinney (and writer, actor, comedian and a host of other talents), reflected on her time dressing up as artists ahead of attending their shows in the 1980s, including Madonna and Sinéad O'Connor. "I've realized that I often mistakenly think back on concerts as having been an experience between the music and me, when in fact the experience was more about my friends and me," Brownstein shares. "That experience was one that began hours, even weeks before the show, often in the form of extraneous activities – like getting dressed (shaving our heads) or listening to the band's recorded music. Getting ready for the show was as ritualized an activity as the show itself; sometimes, it was the most memorable part of all."

It's undeniable that the Swifties see the value in the pre-show rituals that come with seeing Taylor live, but they've taken it even further (hello friendship bracelets). The Eras tour took the Swifties' outfits to new heights, as highlighted in an article titled "For Taylor Swift fans at The Eras Tour, the concert 'fit makes the whole experience shimmer" from June 2023 on *Mashable* by Elena Cavender. She stated, "Fans' outfits draw from Swift's deep catalog and many successful rebrands. For every Swiftie in cowboy boots, there's another in sparkly gogo

boots or white Keds. The premise of the tour encourages nostalgia and reconnecting with moments in both your own and Swift's life. Fans pull imagery from different eras and combine them not only to express that they're diehard fans but to proclaim which albums or moments resonate most."

Taylor Swift fans have been known to have their outfits reference the star since the early days of her career, but the ante was very much upped for the Eras tour. The worldwide tour saw fans show up in styles representing everything from their favourite album era to clever nods to specific lyrics (hello to the key-lime green poodles from "The Last Great American Dynasty").

Journalist Ruby Carter weighed in on the phenomenon, stating in a piece titled "The Summer of Super-Fan Approved Concert Dress Codes" for Little Black Book, "The stans unite under a shared sartorial theme, enhancing the communal experience and creating a sense of belonging. This not only adds to the spectacle of the shows but also fosters a strong sense of camaraderie among the fans."

OVERLEAF Swifties show their love for their favourite singer with their outfits as they wait outside the MetLife Stadium in New Jersey on May 26, 2023.

American high-street label Hazel & Olive became a go-to spot for fans with "The Eras Sequin Fringe Dress" fast becoming a firm favourite. CEO Taylor Johnson told CNN for a 2023 piece titled "Taylor Swift sets summer's hottest dress code: Sequins, boots, cowboy hats" that, "Our phones have been blowing up and we've been getting hundreds of calls and Instagram messages about that dress."

And though we've seen that many retailers have jumped on the chance to produce off-the-rack styles for Swifties to enjoy, the Eras tour was also an opportunity for fans to take a DIY approach with their looks. Seemingly as soon as the iconic tour was announced, TikTok became a haven both for those new to sewing and seasoned pros to create unique replicas of Taylor's famous looks or interpretations of their favourite "era" or lyrics. One Dutch fan, Lotte Lutjes, has made quite a name for herself as the unofficial queen of recreating some of Ms Swift's strongest looks with serious precision. Her TikTok videos showing off her creations have garnered millions of views and plenty of press coverage, including a 2016 MTV article where she shared her thoughts: "Taylor is just so down to earth and she's her own person and doesn't let anyone tear her down. I feel like that attitude is something she teaches her fans as well. She taught me how to deal with feeling left out and alone and so much more."

"Karma is a god, so I am the goddess of Karma. That song was stuck in my head for two weeks, and I didn't know what to wear, so..." Adele McDonald shared ahead of one of Taylor's MetLife Stadium shows in May 2023.

A dedication to reinvention

The challenge of keeping audiences captivated while maintaining integrity and authenticity is not something many performers and artists can manage over long periods of time. Taylor's approach to communicating through the thematic work of her albums and coinciding stylistic approaches to fashion has been a key source of intrigue for fans and casual onlookers alike. Though some may see the prescribed themes are restrictive or proof of a contrived approach, one could also regard this as a natural way for an artist to demonstrate themselves as a multifaceted being with various sides to themselves that they're exploring and performing in an intentional and stylized way.

Taylor's 2022 album, *Midnights*, and accompanying videos crossed genres by bringing in unexpected collaborators such as comedian Mike Birbiglia, who starred in the video for "Anti-Hero" and Ice Spice, who featured on a deluxe version of the track "Karma". Here, the rapper poses with Taylor on stage in East Rutherford, NJ.

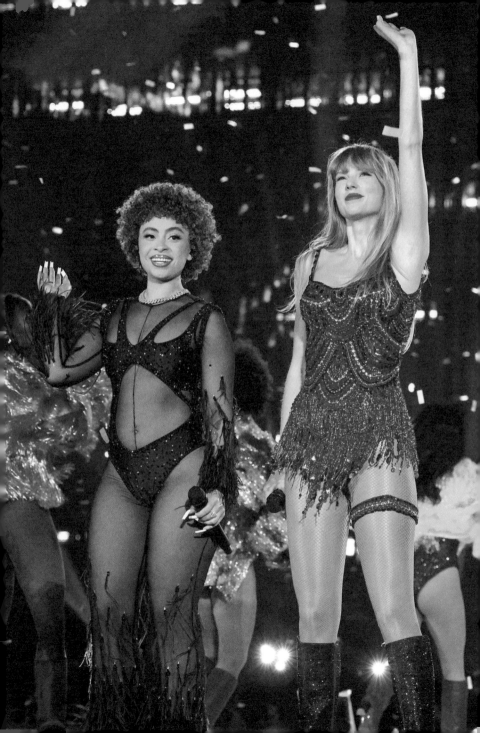

"*I have always been fascinated by women who constantly* question *and* challenge *themselves and Taylor,*

*with her
work, has
demonstrated
to be a multifaceted
artist, able to
constantly*
transform
and evolve"

**ALBERTA FERRETTI,
ITALIAN DESIGNER**

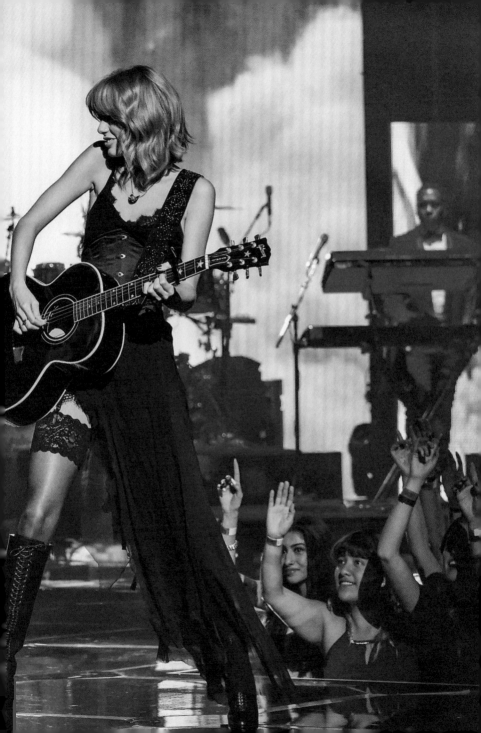

Taylor's dedication to reinvention can be seen as a key component to her success, allowing her albums to act as a kind of gauge for growth and evolution. The theme of reinvention is something she has openly discussed before, notably in her *Miss Americana* documentary (2020). "The female artists that I know of have reinvented themselves 20 times more than the male artists," Ms Swift states in the film, accompanied by flashing footage of styles sported over her career, highlighting their contrast to each other. The tone of this statement could easily be interpreted as the singer showing a resentment toward the demand for freshness from female performers that male performers can seemingly reject without consequence. But, like many things in Taylor's career, we see her take this narrative and flip it on its head in a playful way that demonstrates ownership and proves her resilience as an artist. Vanessa Friedman, Fashion Director at the *New York Times*, highlights this dichotomy in a 2023 article titled "Taylor Swift and the Sparkling Trap of Constant Reinvention" that dissects the theme of reinvention, using the Eras tour shows as a case study. She states: "At one point in the Eras show, when Ms. Swift is singing 'Look What You Made Me Do,' all of the old Taylors are embodied by different

backup dancers in different outfits in different little glass boxes – all those mini-mes of the past, trapped in their own limited spaces, in their old wardrobes, only to finally break free. As fashion metaphors go, it's hard to miss."

One of the female artists that she was perhaps referring to in this *Miss Americana* observation was the one and only Madonna Louise Veronica Ciccone, who reigned Queen of Pop for much of the eighties and nineties (and, of course, still sees her singles topping the charts today). Taylor has noted Madonna as an inspiration throughout her career, including in a 2013 interview with *Billboard Magazine*, where she comments on the star's talent for keeping things fresh, stating, "One element of Madonna's career that really takes center stage is how many times she's reinvented herself. It's easier to stay in one look, one comfort zone, one musical style. It's inspiring to see someone whose only predictable quality is being unpredictable." By 2015, Taylor's own career had skyrocketed to levels of fame that took her vantage point from admiring Madonna from afar to performing the track "Ghosttown" (one of Madonna's tracks from her 2015 album *Rebel Heart*) alongside her at the iHeartRadio Music Awards, a true testament to her success.

New eras

Demonstrating breadth beyond what anyone thought possible when she arrived in the public sphere as a Goldilocks teen, it's nearly impossible to foresee where Taylor Swift's career will take her next. Beyond being a performer and songwriter, her resumé includes acting roles in on-screen productions, including a cameo in the 2014 drama *The Giver*, playing an impish Bengal cat (Bombalurina) in the musical *Cats* (2019) and a brief appearance in *Amsterdam* (2022). She has tried her hand at clothing design – first, age 19 when she designed a range of sundresses for Walmart and then for a collection of *Lover*-inspired apparel in 2019 with Stella McCartney (a leap that, alone, demonstrates her style evolution). Her talents as a director are no secret either, having directed a lengthy list of her music videos, from "Mine" (2010) to "Bejeweled" (2023). Her 2021 release, *All Too Well: The Short Film*, won her an impressive array of awards too, including Best Direction at the 2023 MTV Video Music Awards and screenings at the prestigious 2022 Tribeca and Toronto film festivals.

On November 12, 2021, Taylor attends the New York premiere of *All Too Well: The Short Film* alongside stars Dylan O'Brien and Sadie Sink.

"Swift is always searching for ways to give her storytelling new life – and, so far, is the undisputed champion of that approach"

RHIAN DALY, *NME*

Taylor wears a striking David Koma dress for the red carpet of the MTV Europe Music Awards 2022, held in Düsseldorf, Germany.

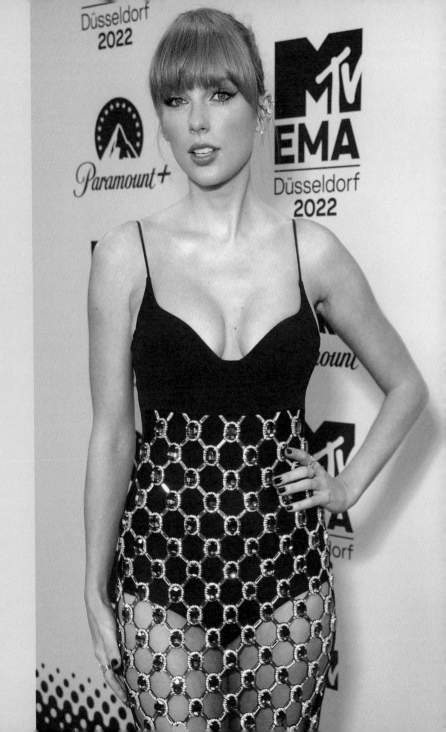

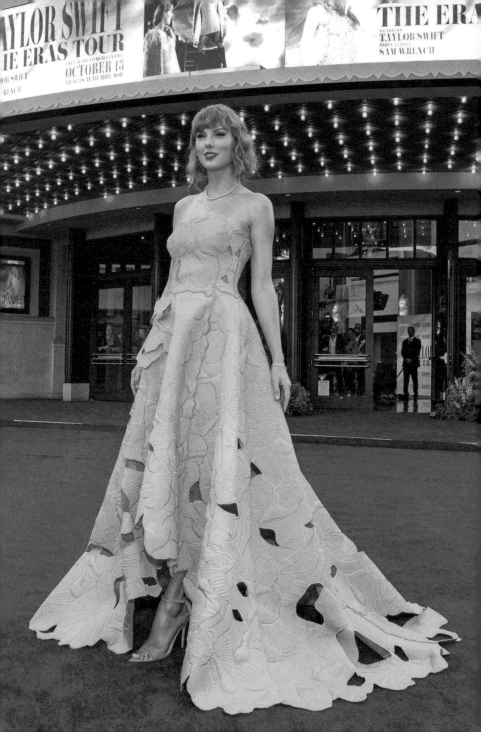

It's clear that Taylor's talents span far and wide – and we've only just begun to see what she's capable of. The impact of the multifaceted artist was summed up by *i-D* writer Tom Haynes in a piece titled "We've reached peak Taylor Swift, is it only down from here?" from 2023. In it he stated: "Any way you slice it, this is Taylor Swift's world and we are simply living in it, even the FBI seems to think so" – in reference to a July 2023 image shared on Twitter that used the *Speak Now* branding to encourage the public to report a crime with the message, "you can help the #FBI protect the country. If you have information about a federal crime, speak now". Haynes goes on to highlight the significance of the Eras tour ticket sales, which were even mentioned in British Parliament after a Cardiff MP flagged the issue of secondary ticketing and the exploitative nature of dishonest sellers increasing the prices tenfold of the face value.

As Taylor's creative endeavours continue to evolve across disciplines and markets, so too does her wardrobe and her undeniable talent to use fashion to bring her messages to life – and her fans will be right there to admire, mimic and dissect the looks for as long as she serves them.

To celebrate the premiere of the *Taylor Swift: The Eras Tour* film on October 11, 2023, Taylor wears a cut-out style in baby blue from Oscar de la Renta.

Index

Credits

The publishers would like to thank the following sources for their kind permission to reproduce the pictures in this book.

6-7 Swan Gallet / WWD / Penske Media / Getty Images; 9 Jesse D. Garrabrant / NBAE / Getty Images; 10-11 Araya Doheny / WireImage / Getty Images; 12 Julian Da Costa / Abaca Press / Alamy Stock Photo; 17 Michael Buckner / Getty Images; 18 Ethan Miller / Getty Images; 20 Jason Squires / WireImage / Getty Images; 23 Jason Kempin / Getty Images; 24 Frazer Harrison / ACM / Getty Images; 25 Peter Kramer / Associated Press / Alamy Stock Photo; 27 Charles Sykes / Associated Press / Alamy Stock Photo; 28 Hoo-Me / Storms Media Group / Alamy Stock Photo; 32-33 Charles Sykes / Associated Press / Alamy Stock Photo; 35 Byron Purvis / AdMedia / Sipa US / Alamy Stock Photo; 36-37 Kevin Mazur / WireImage / Getty Images; 38 Alo Ceballos / FilmMagic / Getty Images; 41 Frank Micelotta / Invision / Associated Press / Alamy Stock Photo; 42 Devin Simmons / AdMedia / Sipa US / Alamy Stock Photo; 45 Alo Ceballos / GC Images / Getty Images; 46 David Crane / MediaNews Group / Los Angeles Daily News / Getty Images; 50 TNYF / WENN Rights Ltd / Alamy Stock Photo; 52-53 Greg Chow / ZUMA Press, Inc. / Alamy Stock Photo; 55 Judy Eddy / WENN Rights Ltd / Alamy Stock Photo; 57 Jamie McCarthy / WireImage / Getty Images; 58 Gotham / GC Images / Getty Images; 61 Tommaso Boddi / WireImage / Getty Images; 63 TAS Rights Management / Getty Images; 64 TAS Rights Management / Getty Images; 67 Unique Nicole / Getty Images; 68 Beulagpinkeu / Wikimedia Commons; 70-71 Lisa Lake / TAS Rights Management / Getty Images; 73 John Shearer / TAS Rights Management / Getty Images; 74 Gotham / GC Images / Getty Images; 76 Axelle / Bauer-Griffin / FilmMagic / Getty Images; 83 Marc Piasecki / FilmMagic / Getty Images; 84 Raymond Hall / GC Images / Getty Images; 87 Papjuice / Bauer-Griffin / GC Images / Getty Images; 88 Kristin Callahan / Everett Collection Inc / Alamy Stock Photo; 90 MEGA / GC Images / Getty Images; 91 Robert Kamau / GC Images / Getty Images; 93 WENN Rights Ltd / Alamy Stock Photo; 94 Jason Kempin / TAS Rights Management / Getty Images; 97 Imaginechina Limited / Alamy Stock Photo; 98-99 Matt Sayles / Invision / Associated Press / Alamy Stock Photo; 100-101 Tommaso Boddi / WireImage / Getty Images; 102-103 Michael Loccisano / Getty Images; 104 Jeff Kravitz / TAS Rights Management / Getty Images; 106 Jeff Kravitz / TAS Rights Management / Getty Images; 108-109 Jeff Kravitz / TAS Rights Management / Getty Images; 111 Dimitrios Kambouris / WireImage / Getty Images; 114-115 Charles Sykes / Invision / Associated Press / Alamy Stock Photo; 117 Axelle / Bauer-Griffin / FilmMagic / Getty Images; 118 Larry Busacca / Getty Images; 120 John Shearer / Getty Images; 122-123 Jay L. Clendenin / Los Angeles Times / Getty Images; 127 Xavier Collin / Image Press Agency / Alamy Stock Photo; 128-129 Evan Agostini / Invision / Associated Press / Alamy Stock Photo; 133 Shutterstock; 134 NCP / Star Max / GC Images / Getty Images; 137 FameFlynet / Splash News / Shutterstock; 138 Gotham / GC Images / Getty Images; 139 Gotham / GC Images / Getty Images; 141 Swarbrick / INFphoto / Cover Images; 143 Neil Mockford / FilmMagic / Getty Images; 144 NCP / Star Max / GC Images / Getty Images; 147 Gotham / GC Images / Getty Images; 149 Emily Woodfield; 150 Gotham / GC Images / Getty Images; 153 NCP / Star Max / GC Images / Getty Images; 154 FameFlynet / Splash News / Shutterstock; 156 WENN Rights Ltd / Alamy Stock Photo; 157 Splash News / Shutterstock; 158 Gotham / GC Images / Getty Images; 159 Gotham / GC Images / Getty Images; 161 Paul J. Froggatt / FamousPixs / Alamy Stock Photo; 162 Axelle / Bauer-Griffin / FilmMagic / Getty Images; 167 Richard Shotwell / Invision / Associated Press / Alamy Stock Photo; 168 Axelle / Bauer-Griffin / FilmMagic / Getty Images; 171 Amy Sussman / Getty Images; 172-173 Bob Levey / TAS Rights Management / Getty Images; 175 WENN Rights Ltd / Alamy Stock Photo; 176 Raymond Hall / GC Images / Getty Images; 177 Splash News / Shutterstock; 178 Imaginechina Limited / Alamy Stock Photo; 180 Raymond Hall / GC Images / Getty Images; 181 Gotham / GC Images / Getty Images; 184-185 Kevin Mazur / WireImage / Getty Images; 186 Robert Kamau / GC Images / Getty Images; 191 Amy Sussman / Getty Images; 194-195 Gary Coronado / Los Angeles Times / Getty Images; 196 Gotham / GC Images / Getty Images; 199 Gotham / GC Images / Getty Images; 202-203 Anthony Behar / Sipa US / Alamy Stock Photo; 205 Adele McDonald, Photo by Marissa Alper; 207 Kevin Mazur / TAS Rights Management / Getty Images; 210-211 Kevin Mazur / Getty Images; 214 Dimitrios Kambouris / Getty Images; 217 Kevin Mazur / WireImage / Getty Images; 218 Chris Pizzello / Associated Press / Alamy Stock Photo.